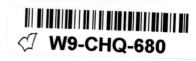

To Judy,
Best Wishes

MILLE LACS

Doy R_____

To my wonderful wife, Rhonda.

INTRODUCTION

I first set eyes on Mille Lacs Lake almost 20 years ago, on a fishing trip with my father. First appearances were deceptive. Pines and maples sheltered the shore, and our rental cabin gave a human scale to the views of the big lake. Mille Lacs looked manageable from the dock. But out in the middle, in our small motorboat, the scale was grand, and the sense of exposure was great. I grew up near Chicago, and of course I knew Lake Michigan, but I had never encountered anything like this broad, shallow body of water that was both epic in scale and intimate in experience.

Mille Lacs is famous as one of the best walleye fisheries in North America, and of course, we were there to fish. We weren't disappointed. Each day ended with a feast of fresh walleye — breaded and fried so that the skin was crisp, crunchy and salty, and the flesh flaky and tender.

As much as I love fishing, my passion is photography. So I also relished Mille Lacs as a source of visual wonder. As we floated in our small boat, I became entranced with the lake as a lens that held the sky and everything in it. On calm days the surface was a mirror, with clouds drifting by below as well as above; the illusion made it seem as though we could be flying instead of floating. When the breeze suddenly came up, riffling the surface and pushing our boat until it pulled on the anchor line, the lake became the embodiment of the wind. In the evening, when the sun hit the horizon and the western sky blazed with fiery reds and oranges, the lake doubled the intensity of the display. We were there for the best show on earth. At this point there was no doubt we were very eager to return. As the vacation came to a close, we marked the calendar for our next trip. We came back every year, and each time it got harder to leave.

Five years ago, my wife Rhonda and I came here and made these shores our home. However, familiarity has not dulled my passion for Mille Lacs. Over the past five years, photography became my documentary obsession.

In my quest for images, I have driven the lake's perimeter dozens of times. I've crisscrossed the surface in boats and canoes, hiked its rocky and sandy shores and endured -30 below windchills. I've been to powwows, windsurfing events, parades and flown thousands of feet above.

I also feel lucky in my encounters with the wildlife sightings. They range from the elusive albino deer (that never fail to surprise me) to the amazing and eerie loon, with its bizarre mating dances on the water and its unearthly night time song.

After all this time, I'm still awestruck by the moods of Mille Lacs — how in an instant it can go from being sunny and serene to an ominous dark gray fury, with five-foot swells slamming around any boat unlucky enough to be in its grip. I've sat in a boat, with my graphite rod literally buzzing with electricity from a looming thunderstorm, and fled knowing my life was in the balance.

Mille Lacs' winter rampages are every bit as exciting as its summer furies. I love tracking across the lake's many ice roads during a blizzard, when I find I've entered a whole different planet. I have come to deeply respect the power of the lake, while at the same time reveling in the opportunity to try to capture its majesty and power with my cameras.

I have endeavored to make this book of photos an indelible memoir of the lake, its people, its wildlife and its amazing showcase of water and sky. All images were taken with digital cameras. While certain effects and manipulation have been achieved through computer software, I stuck as close to the source material as possible in order to provide the most accurate rendition of the subject. After all, reality needn't be manipulated when intensities of varied natural light, color and form are on display at Mille Lacs every day.

— Doug Bennington

LAKE FACTS

- French fur traders named this area of central Minnesota "Pays de Mille Lacs," or Region of a Thousand Lakes. They called this lake "Grand lac du Pays de Mille Lacs," which was later shortened by English speaking settlers to Mille Lacs Lake.

- The lake has 100 miles of shoreline, 207 square miles of lake surface, a maximum depth of 42 feet, and is 1,251 feet above sea level.

- Mille Lacs is the second largest lake entirely within Minnesota's borders. (Red Lake is the biggest).

- Retreating glaciers from the last Ice Age created Mille Lacs, along with most of Minnesota's other lakes, about 10,000 years ago.

- Winter ice forms as thick as four feet over the entire surface, which makes Mille Lacs one of Minnesota's most popular places for ice fishing.

- Unlike many North American lakes, broad, shallow Mille Lacs does not have a thermocline — the thin layer of water that separates the warmer surface from the cold depths. Because of this lack of layering, fish can swim at all depths year-round.

- Fish species include: bluegill, crappie, cisco (tullibee), eelpout, muskellunge, northern pike, smallmouth bass, walleye and yellow perch. With a 100% naturally reproducing walleye population, no restocking is required.

- The Minnesota state record muskie is 54 pounds, caught in 1957 at Lake Winnibigoshish, Itasca county. The DNR has confirmed an even bigger one lurks in the depths of mighty Mille Lacs.

- The lake's main outflow is the Rum River.

- The lake straddles the three counties of Aitkin, Crow Wing and Mille Lacs.

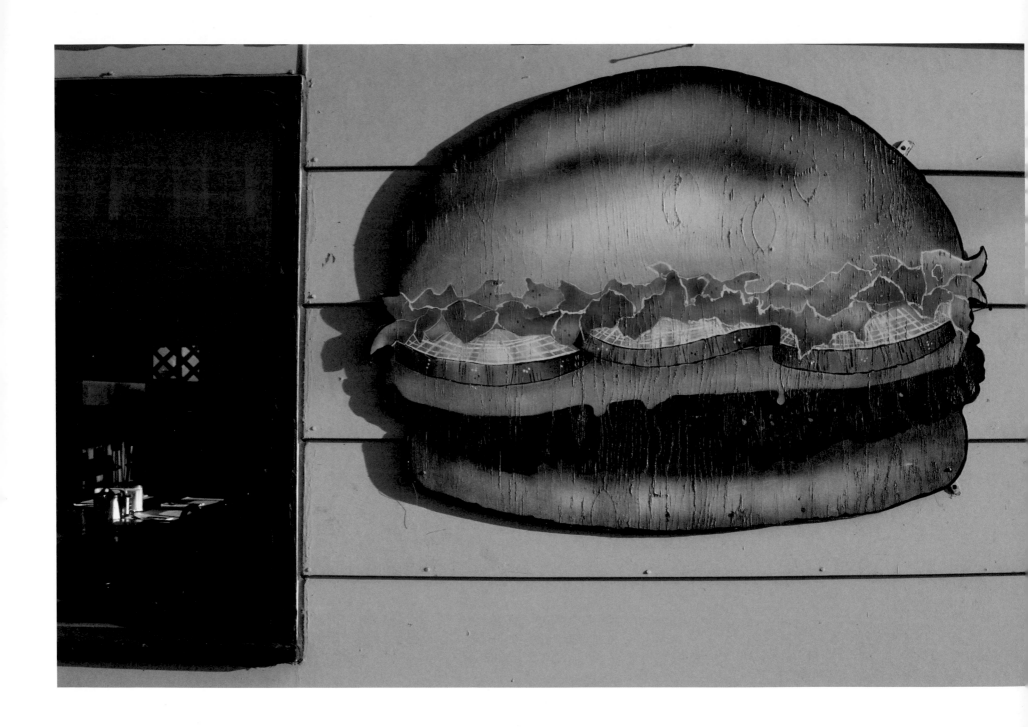

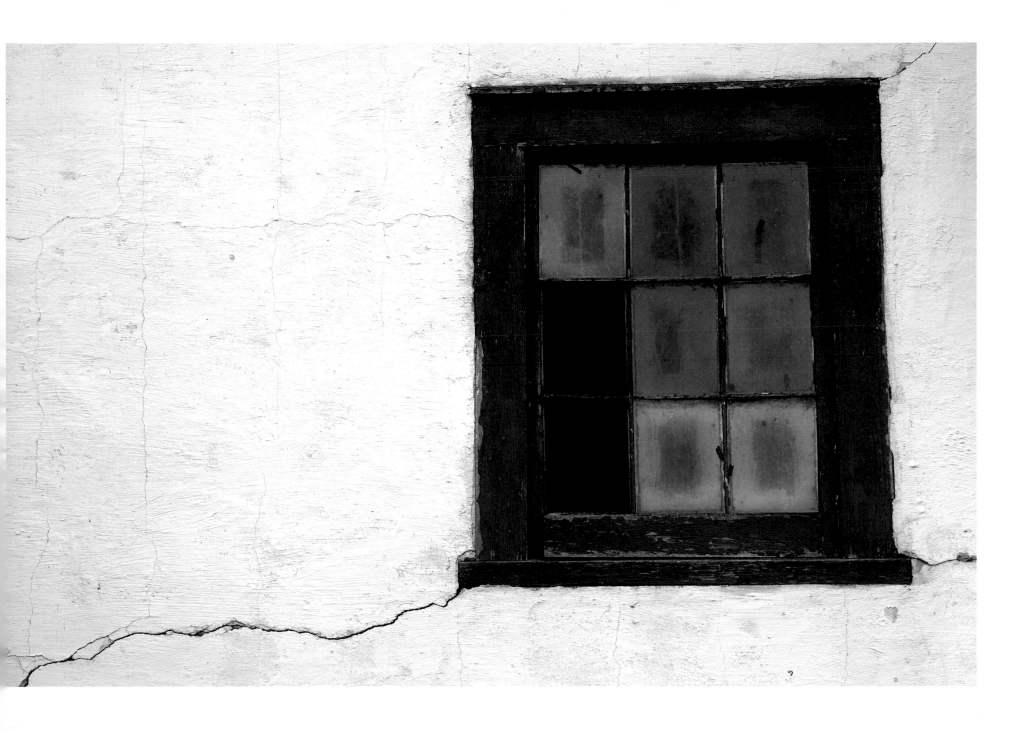

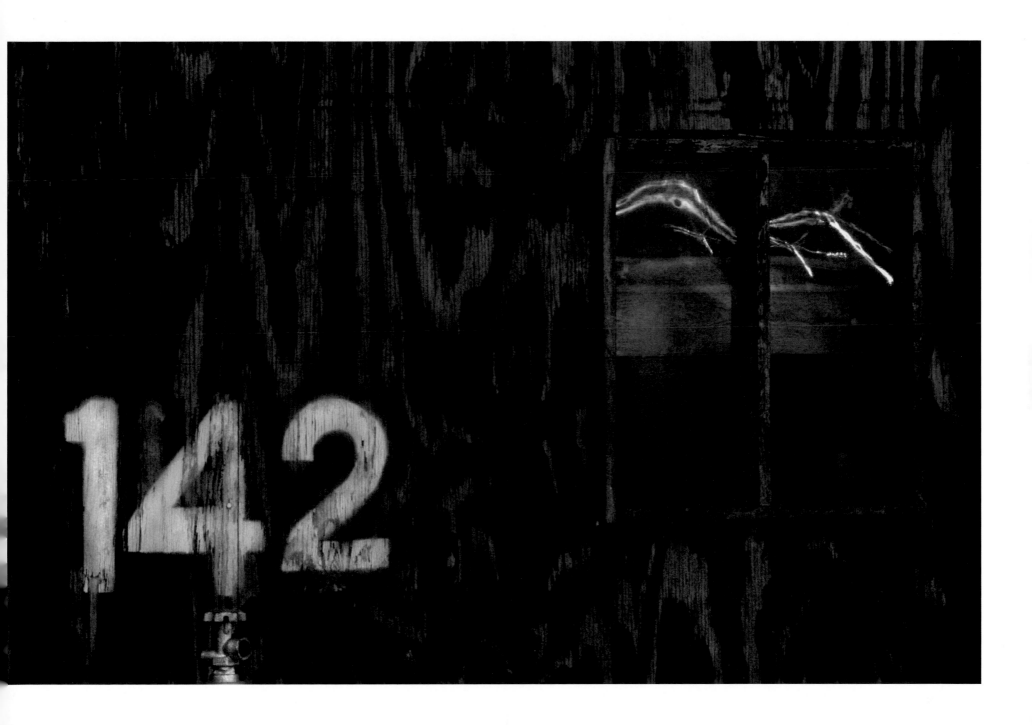

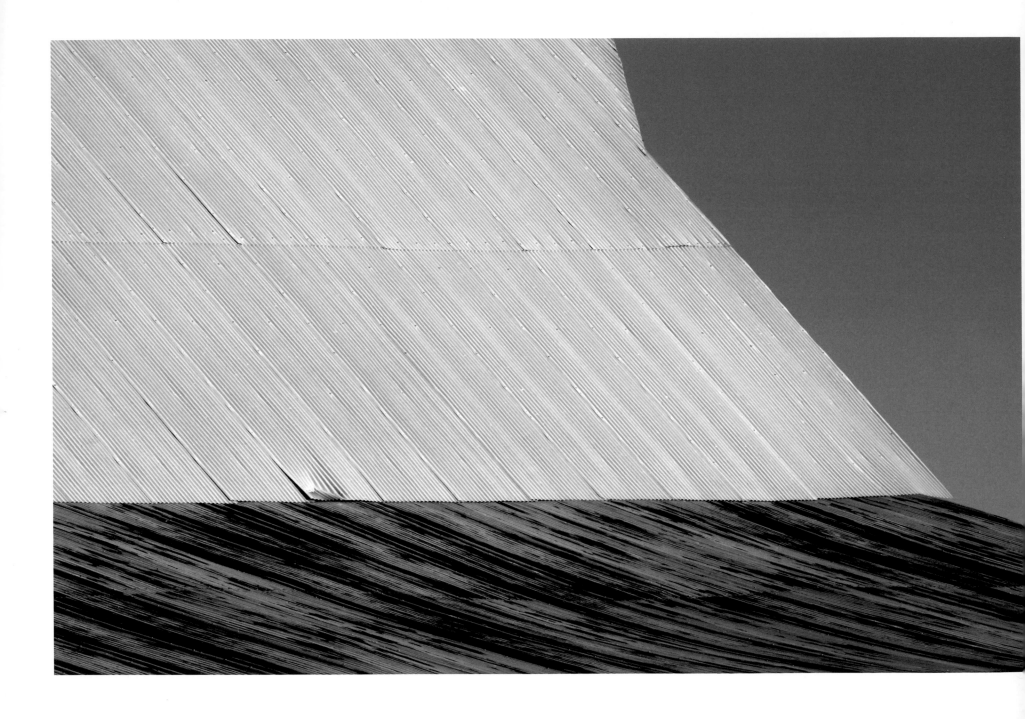

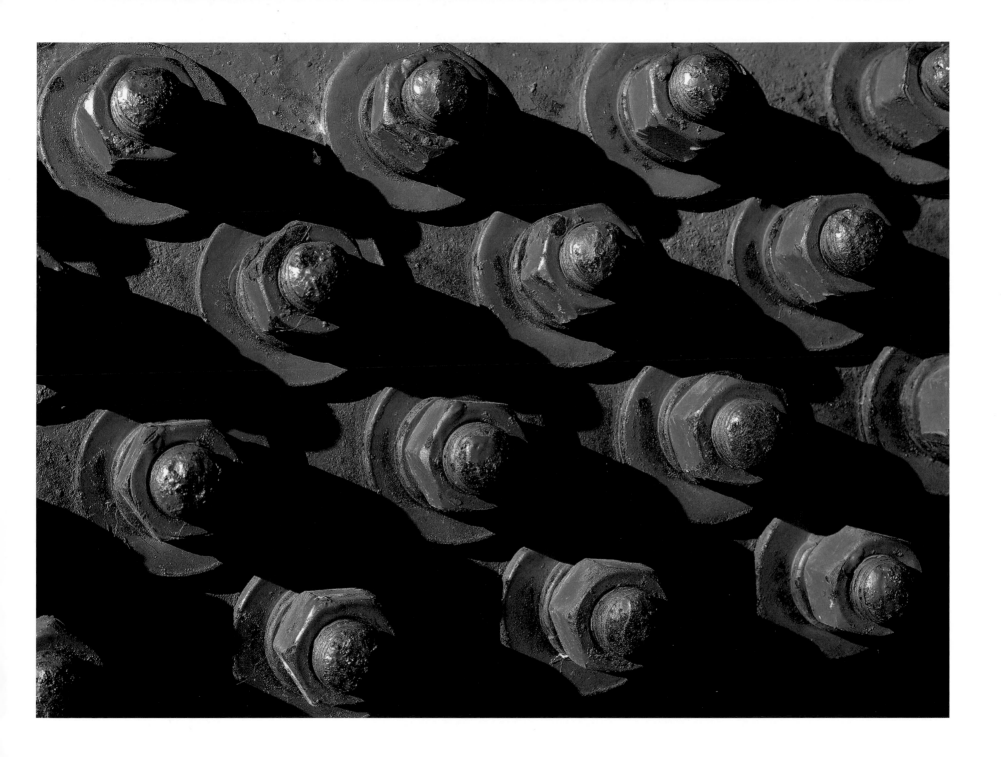

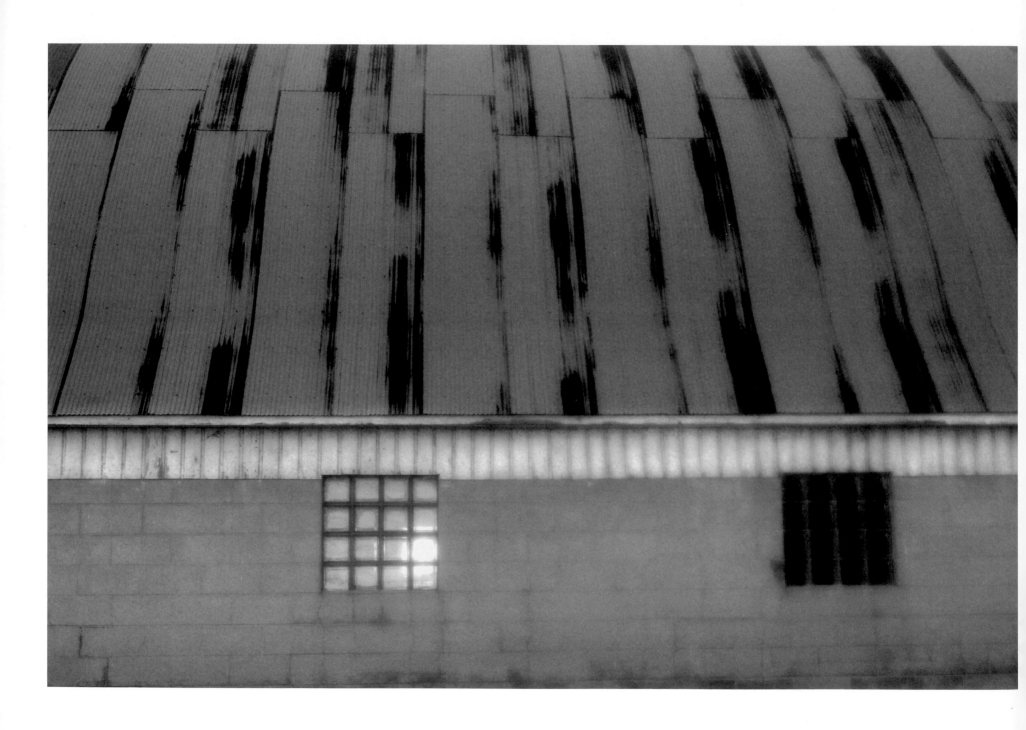

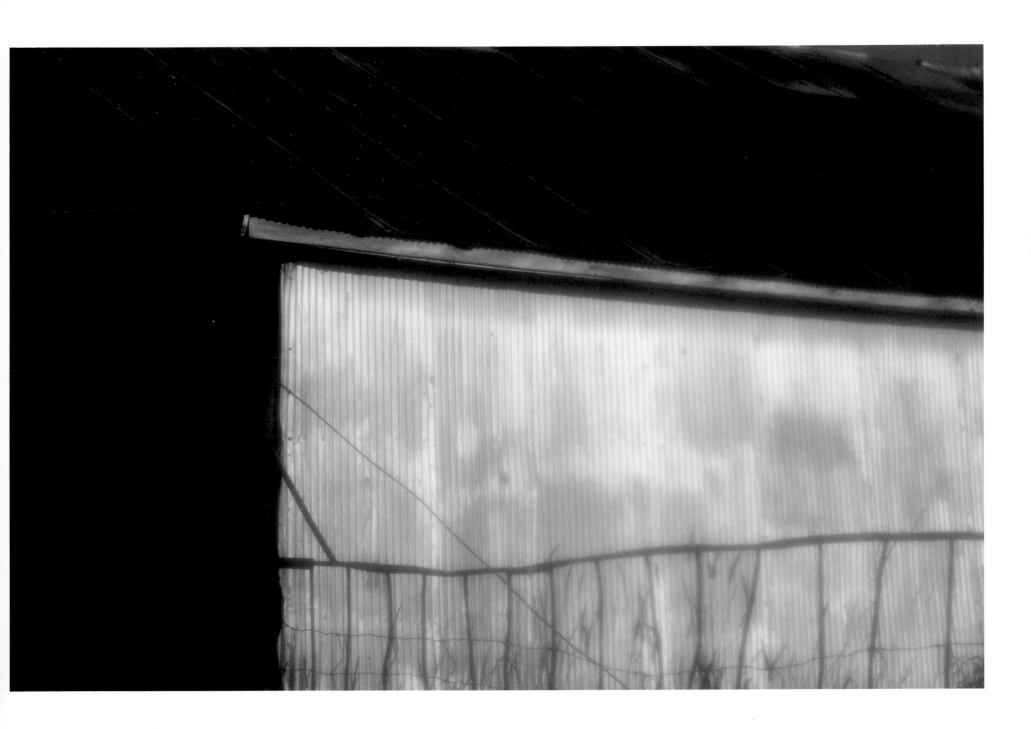

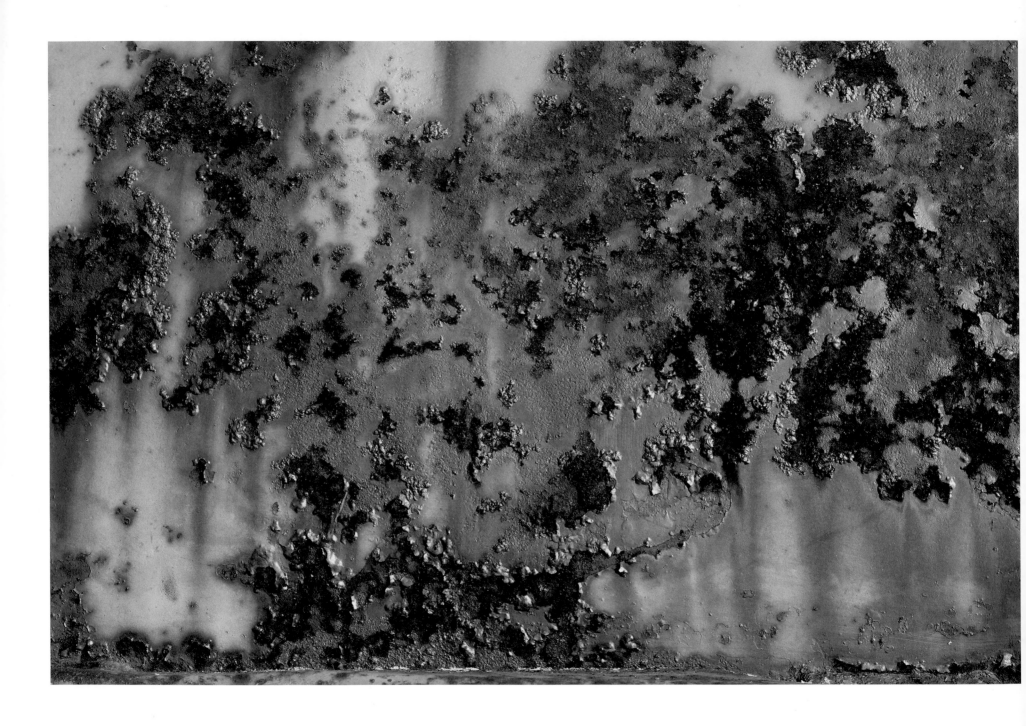

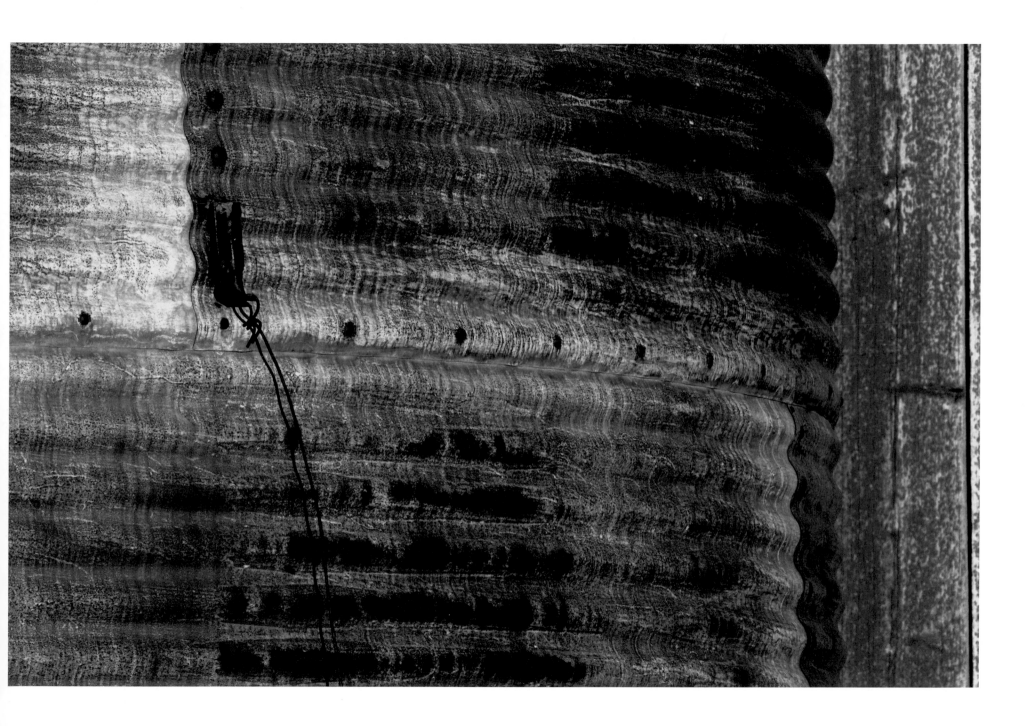

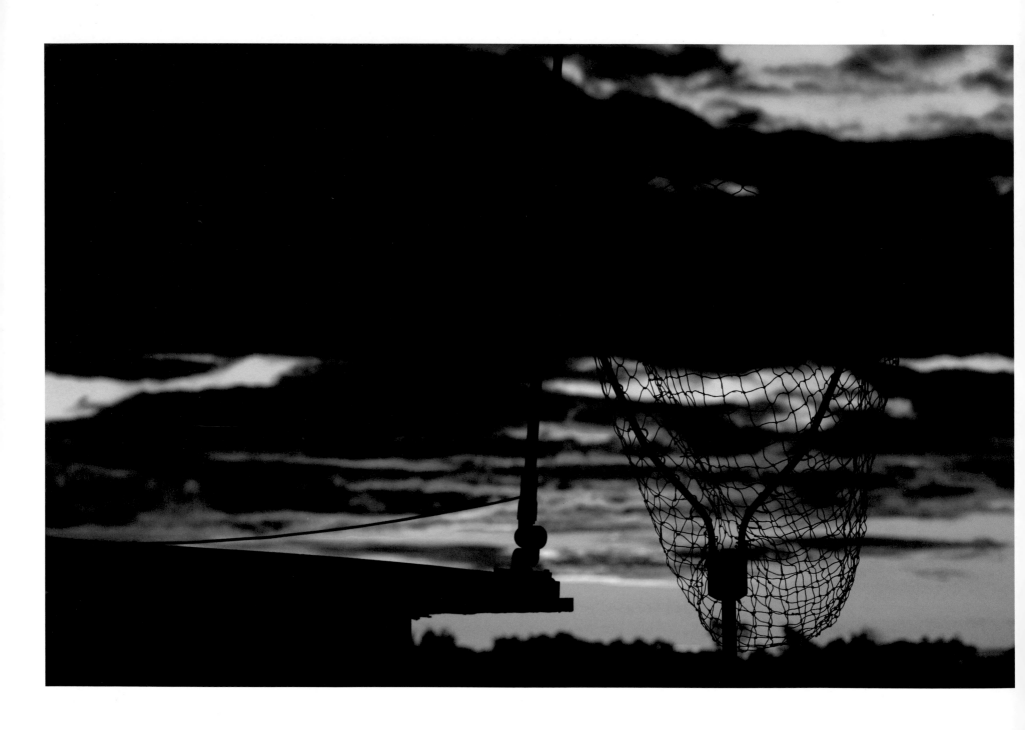

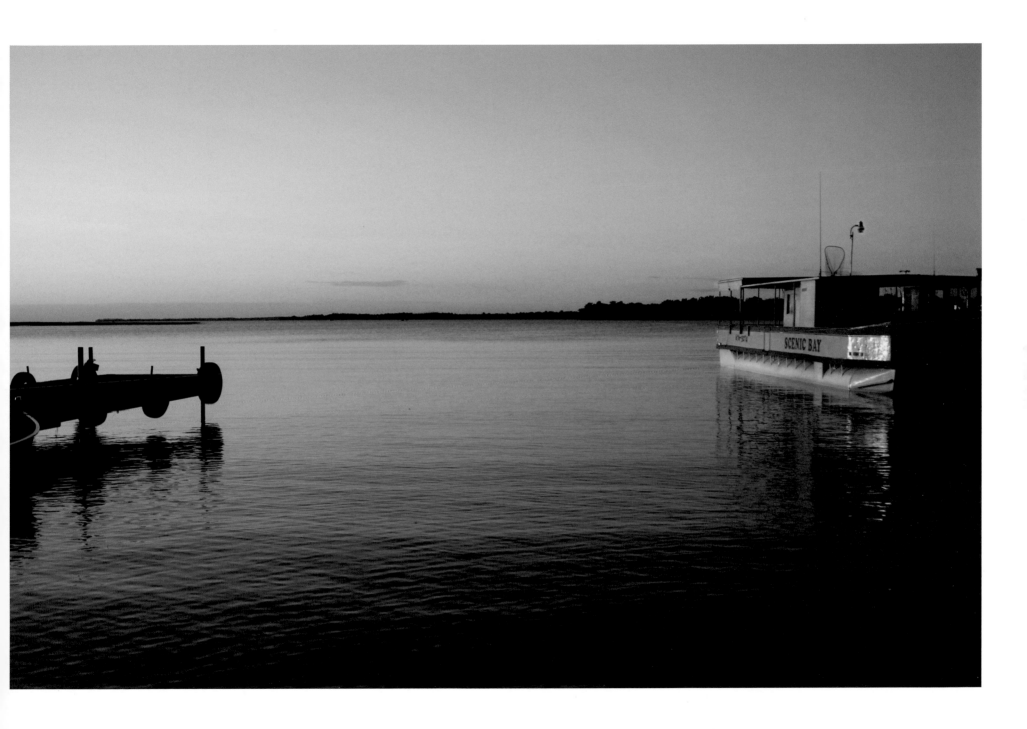

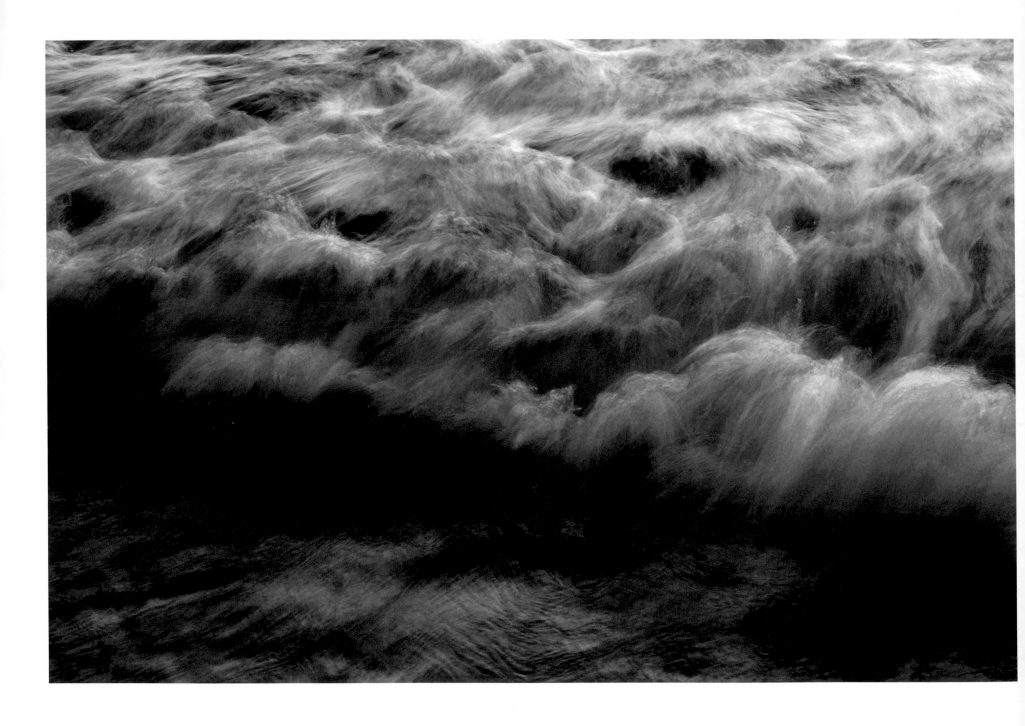

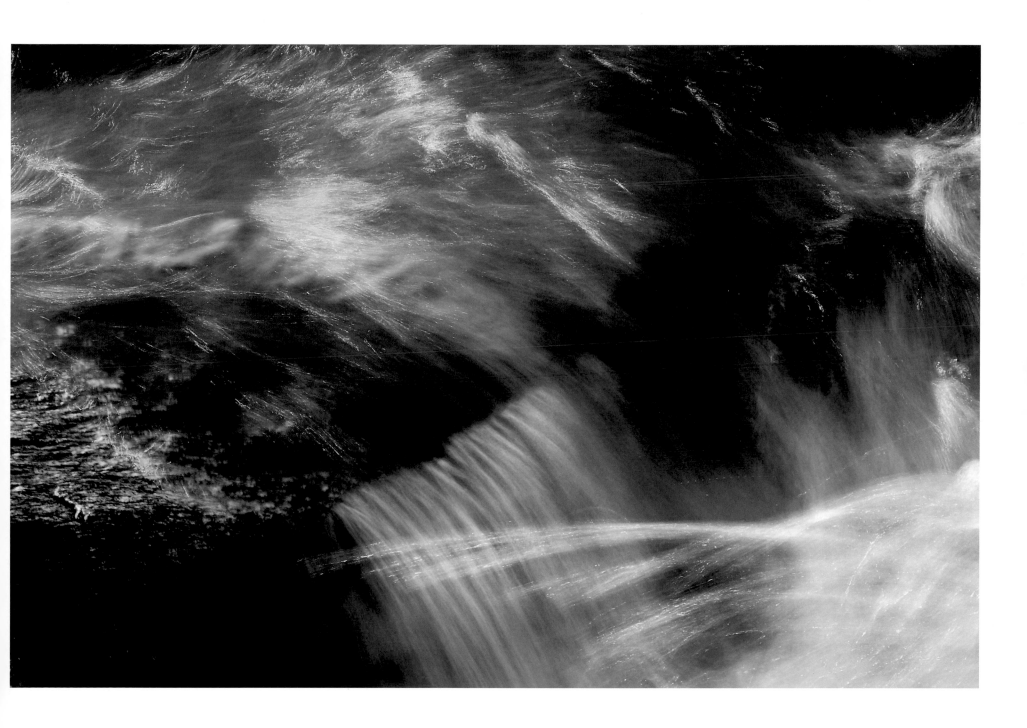

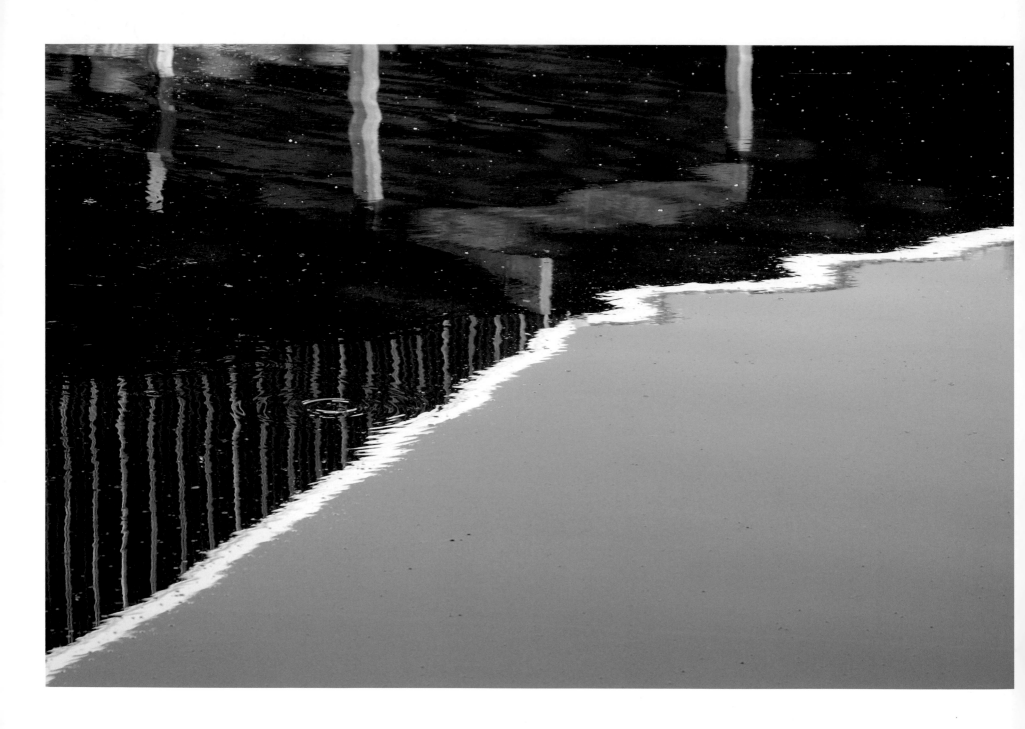

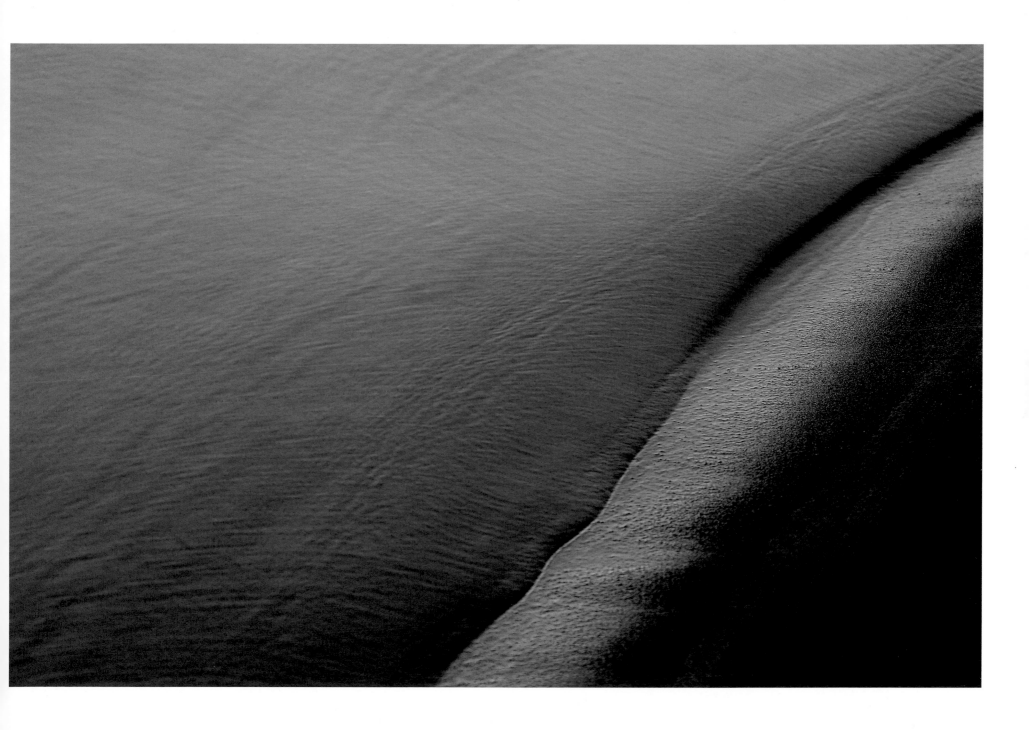

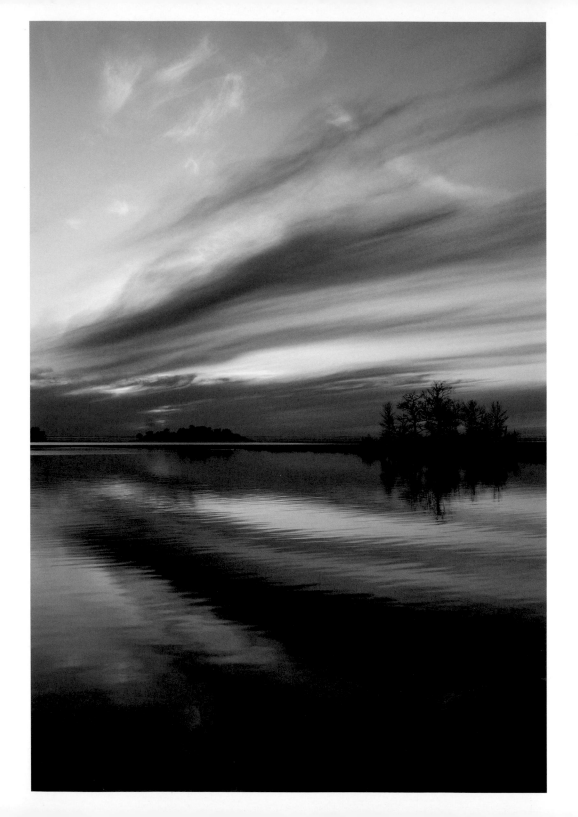

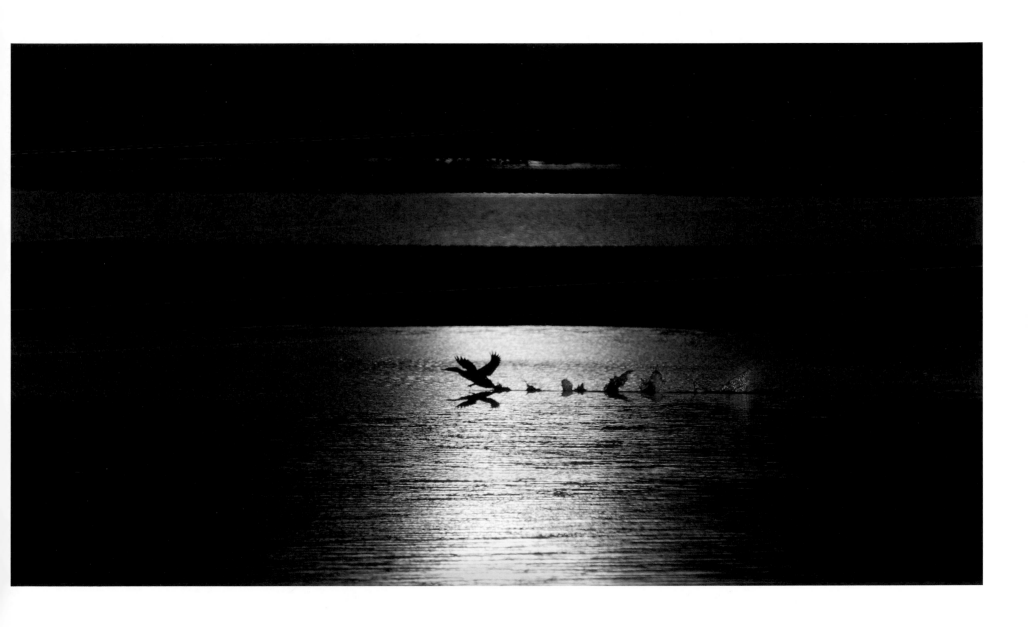

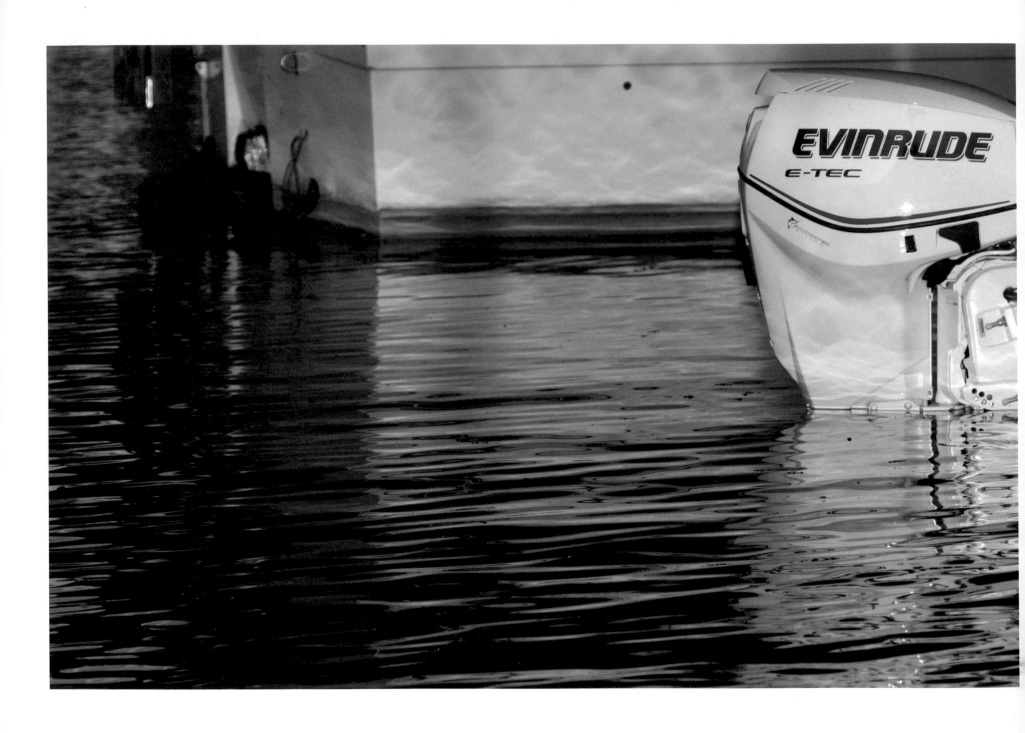

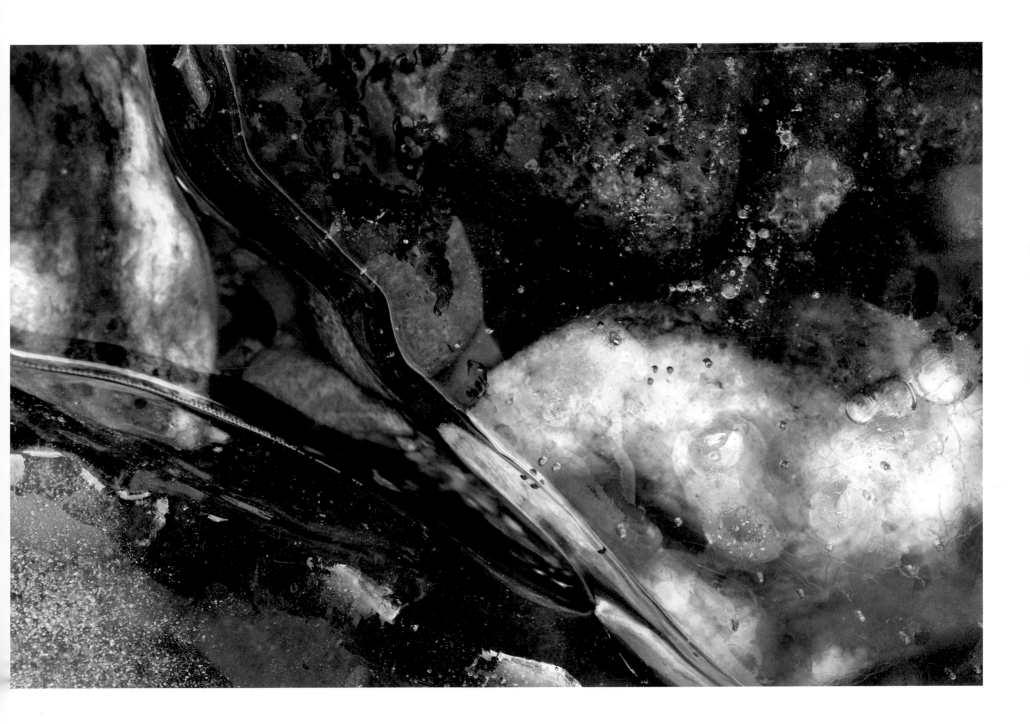

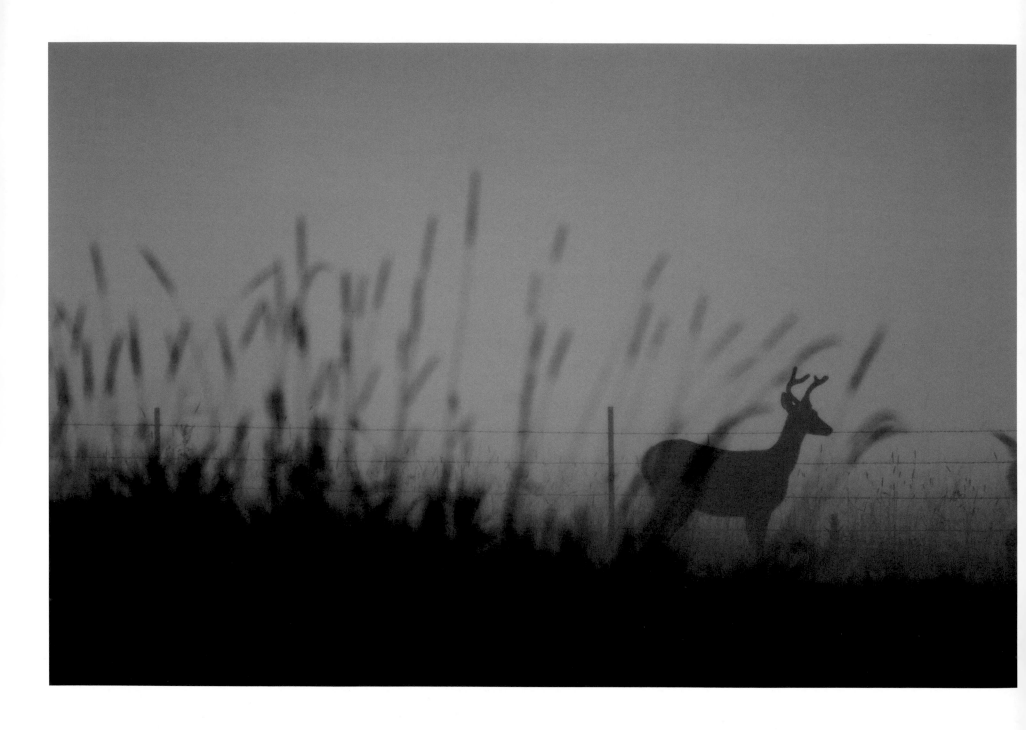

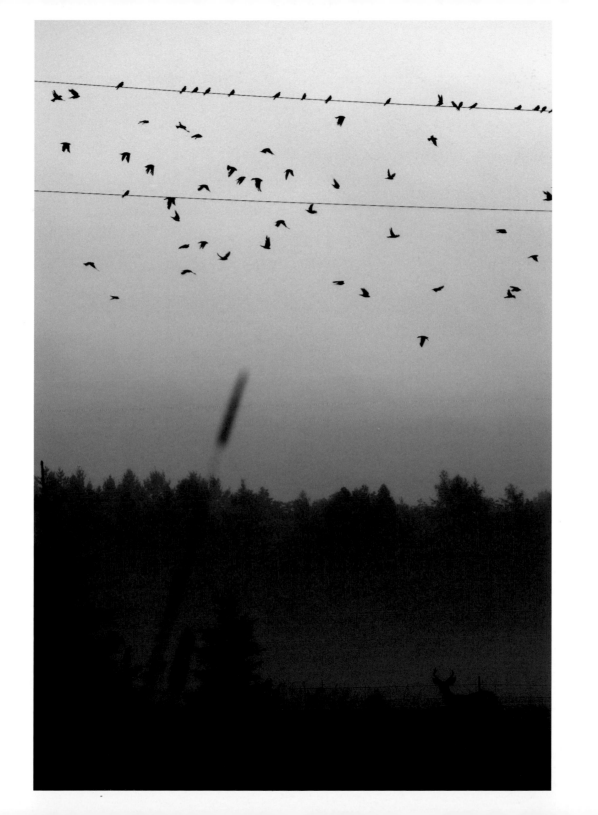

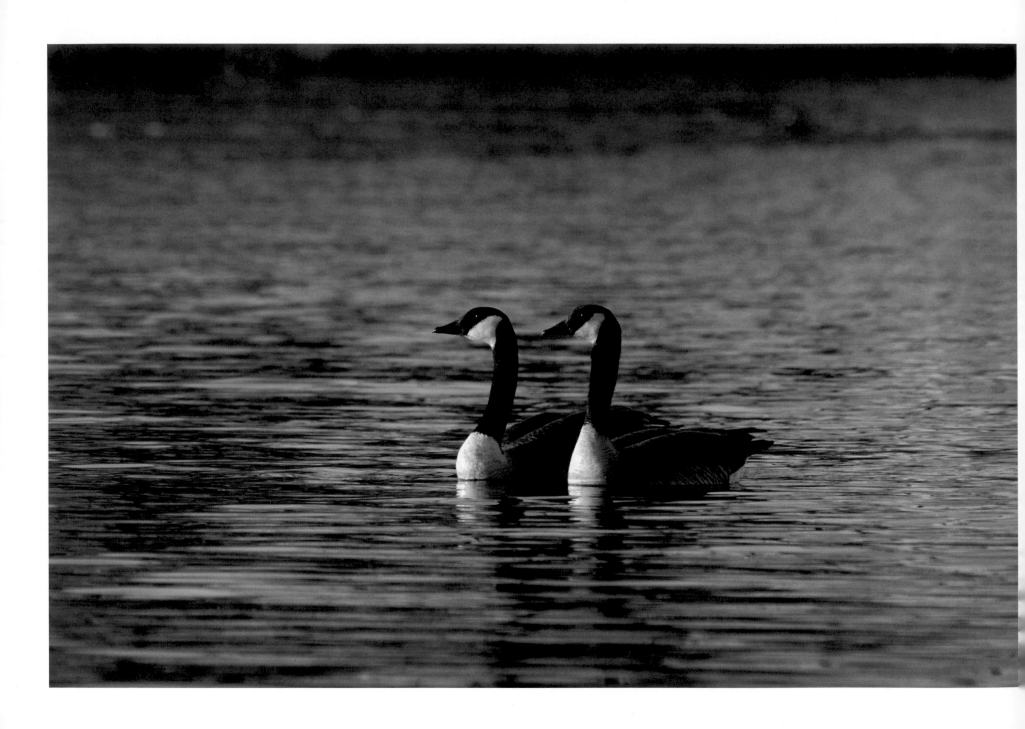

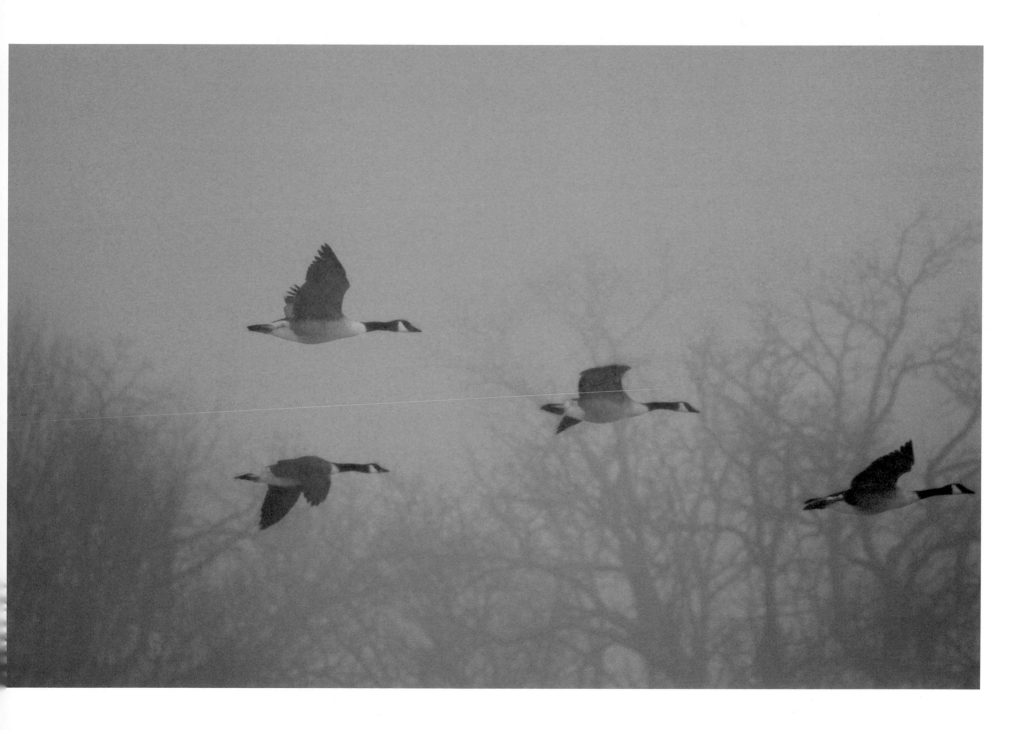

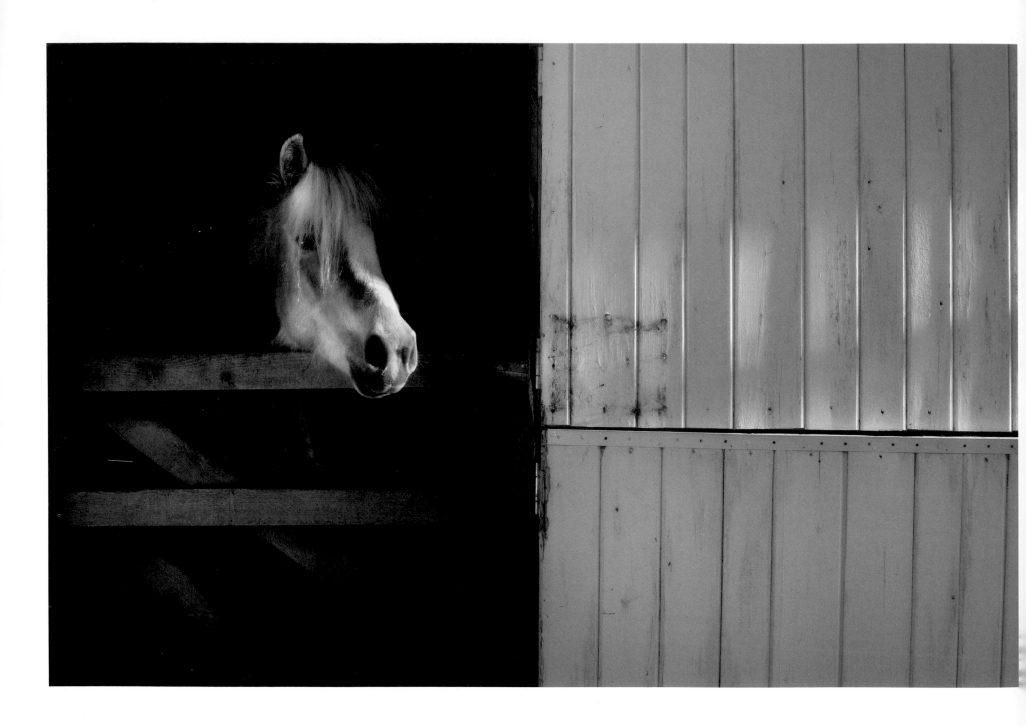

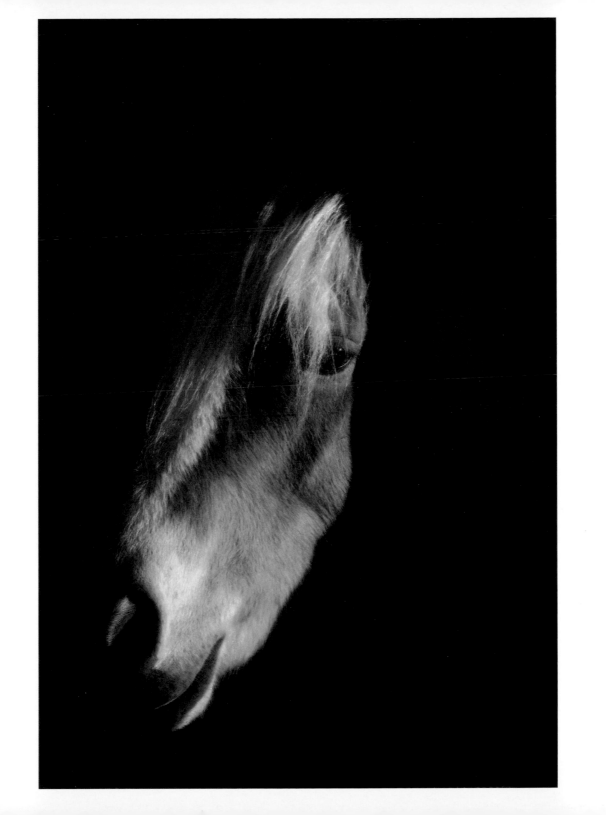

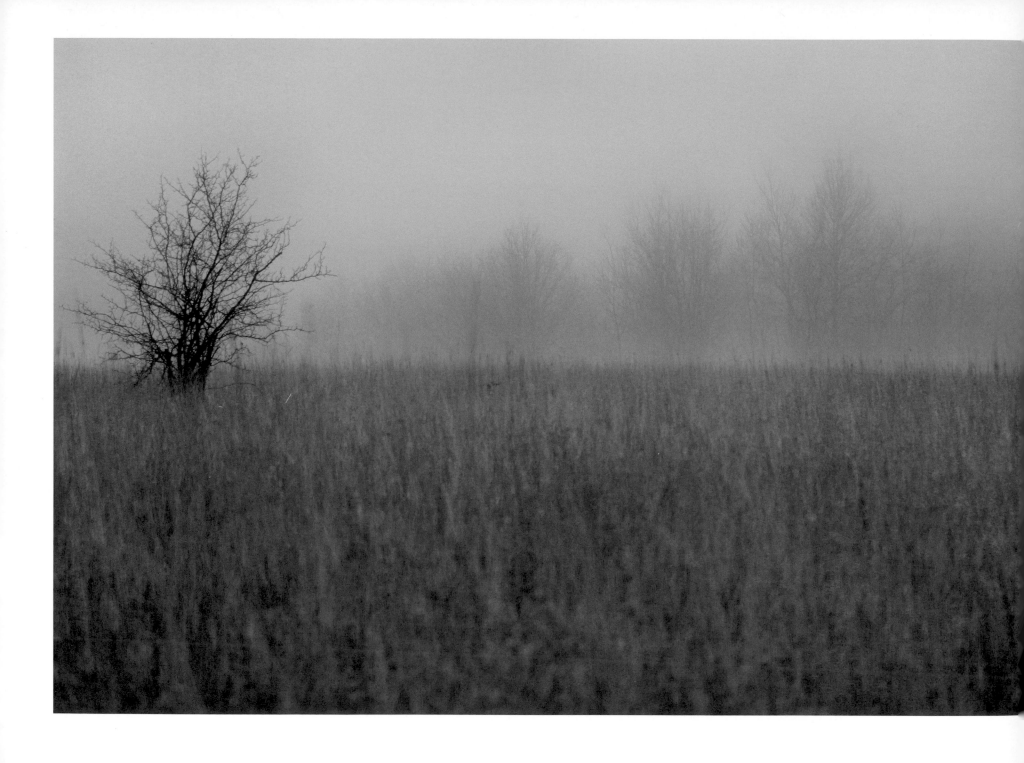

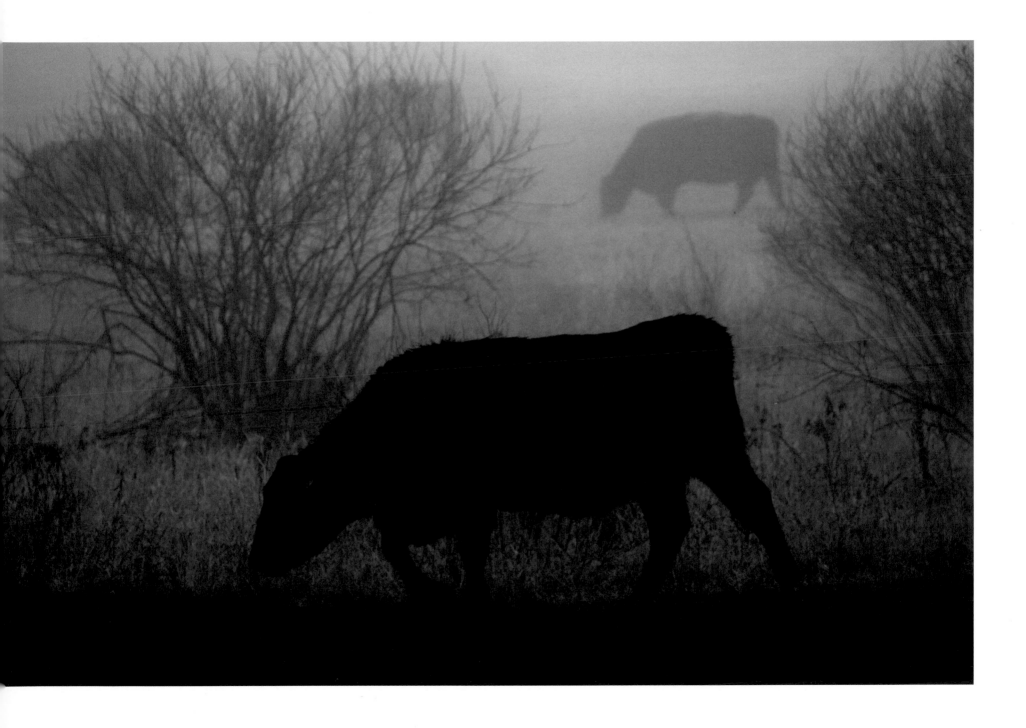

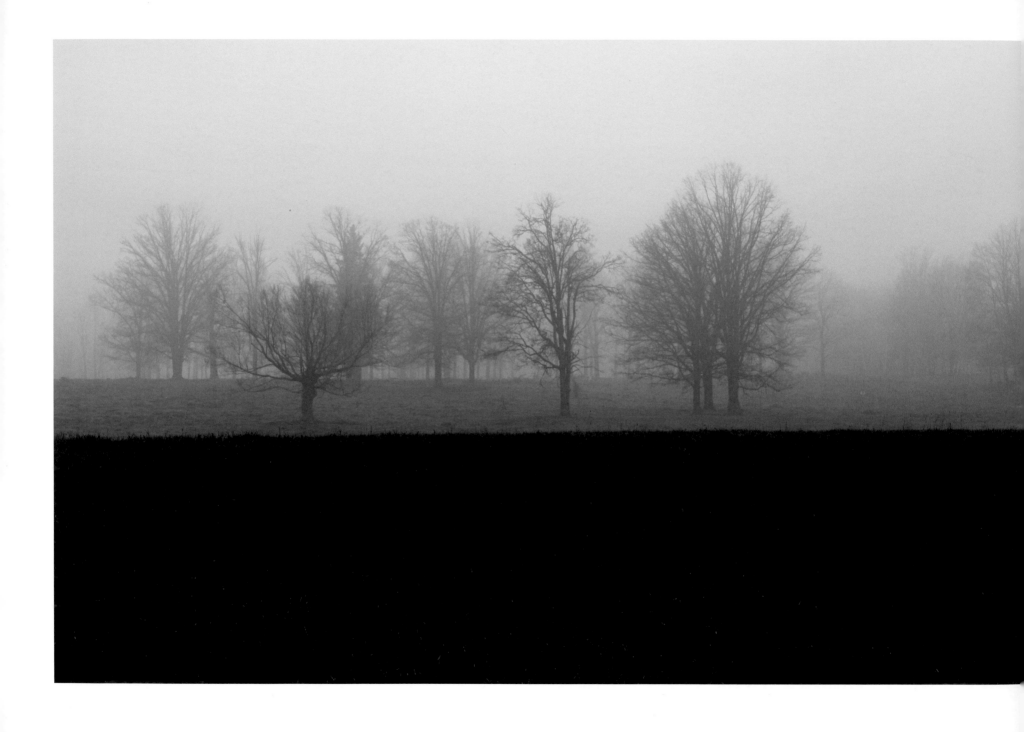

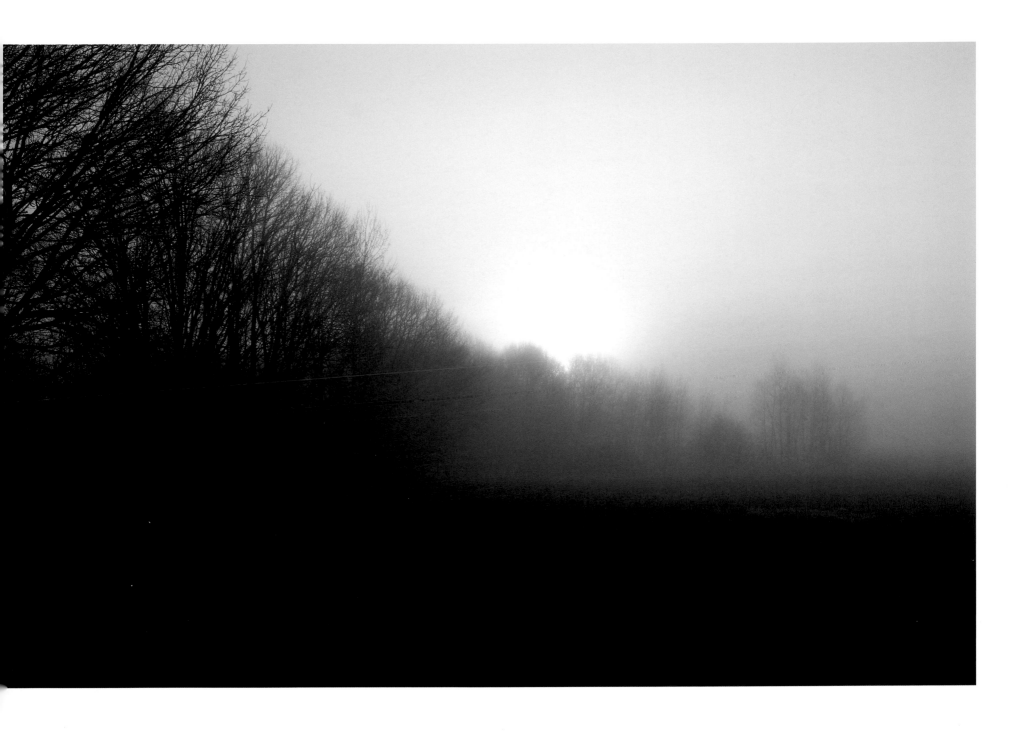

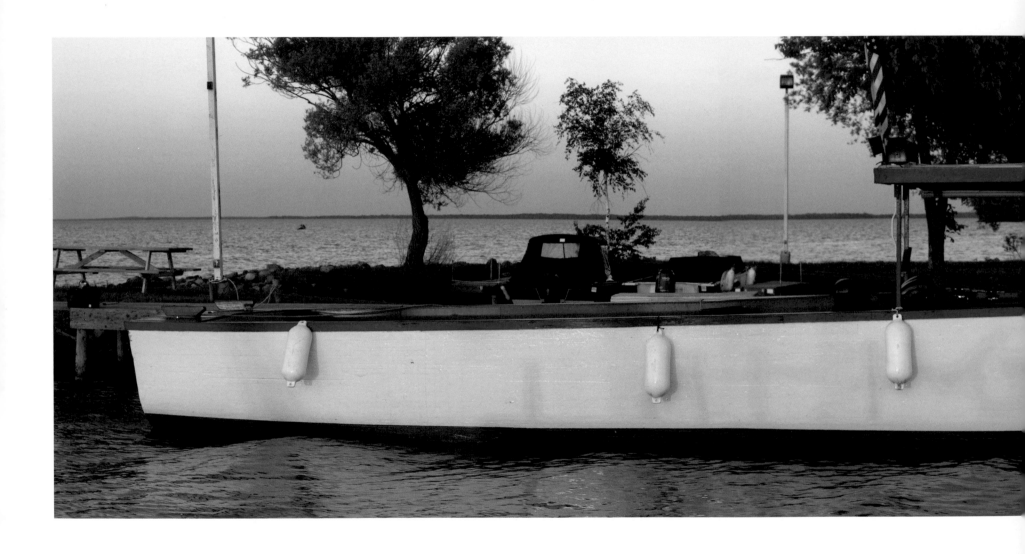

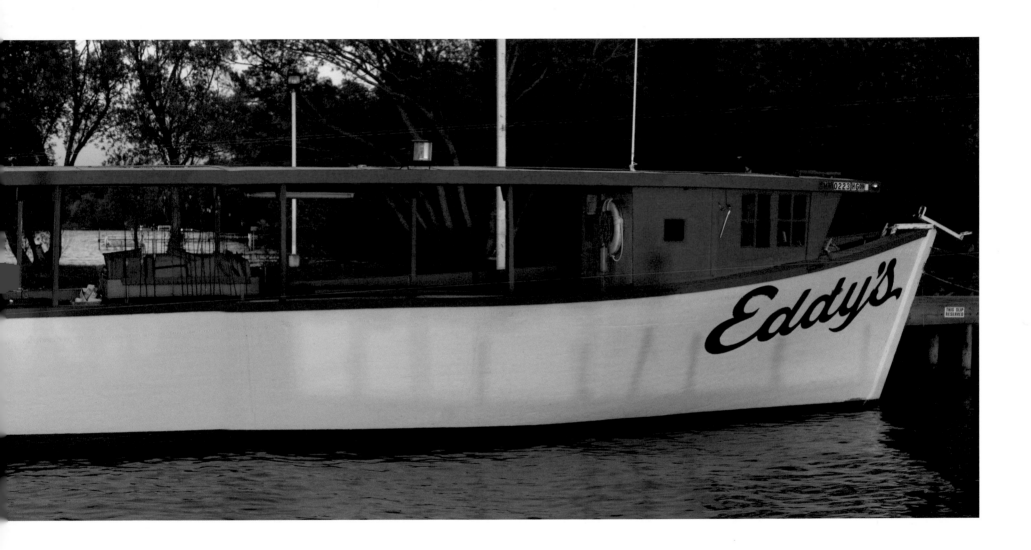

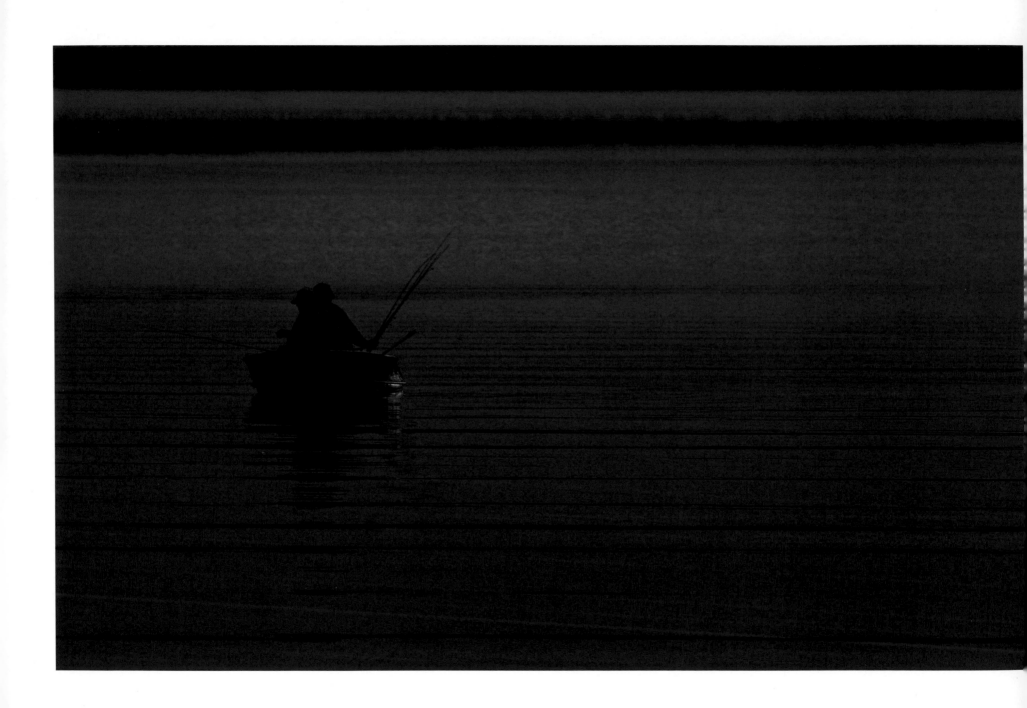

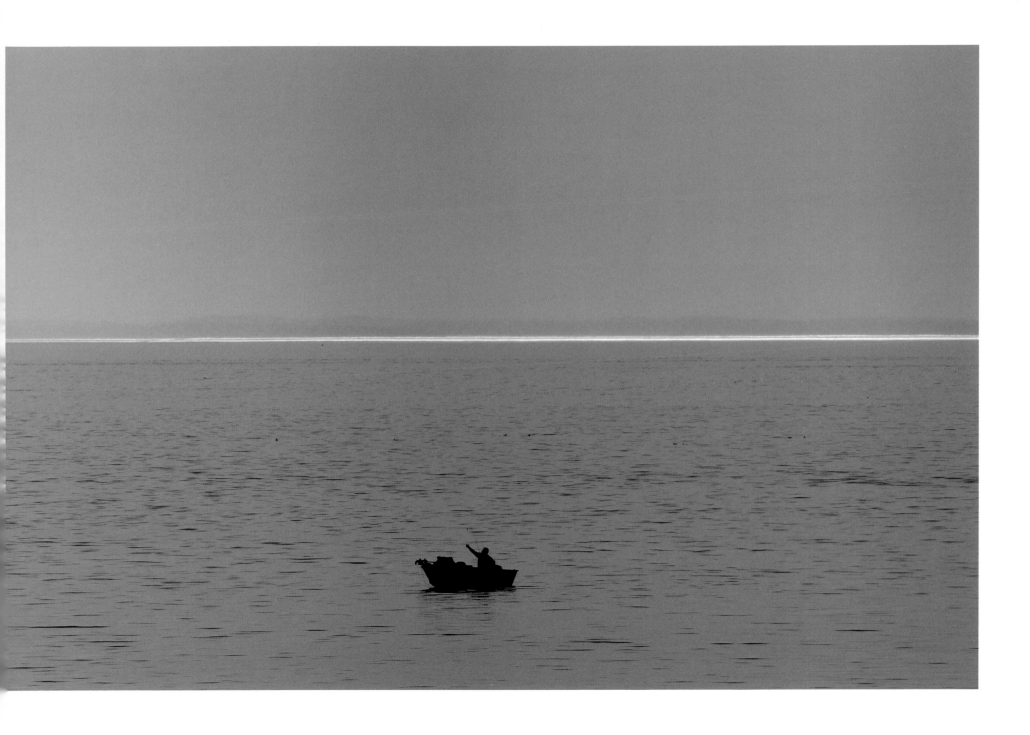

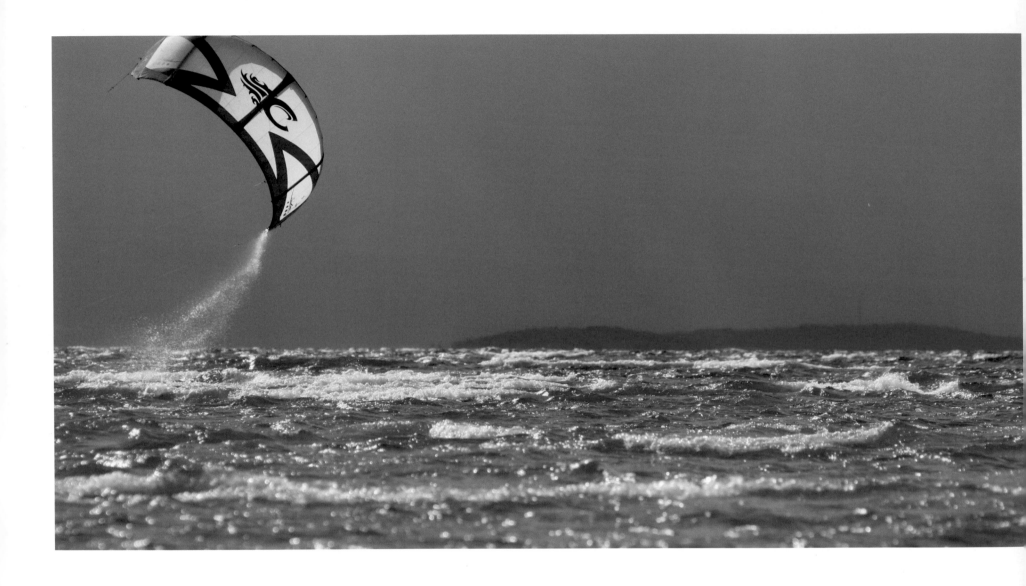

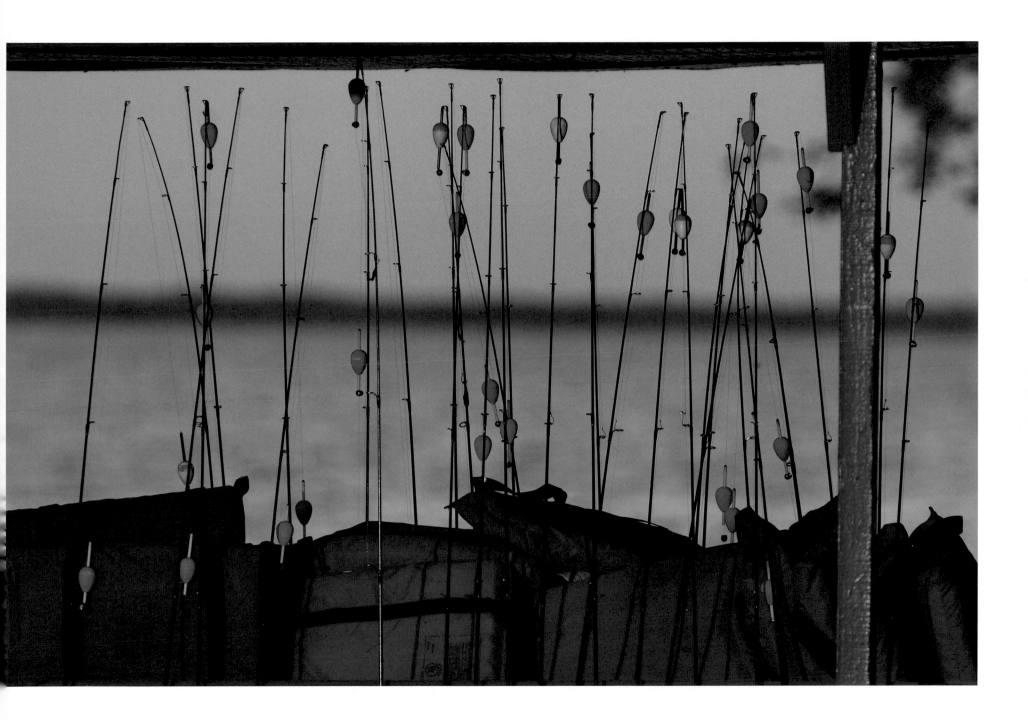

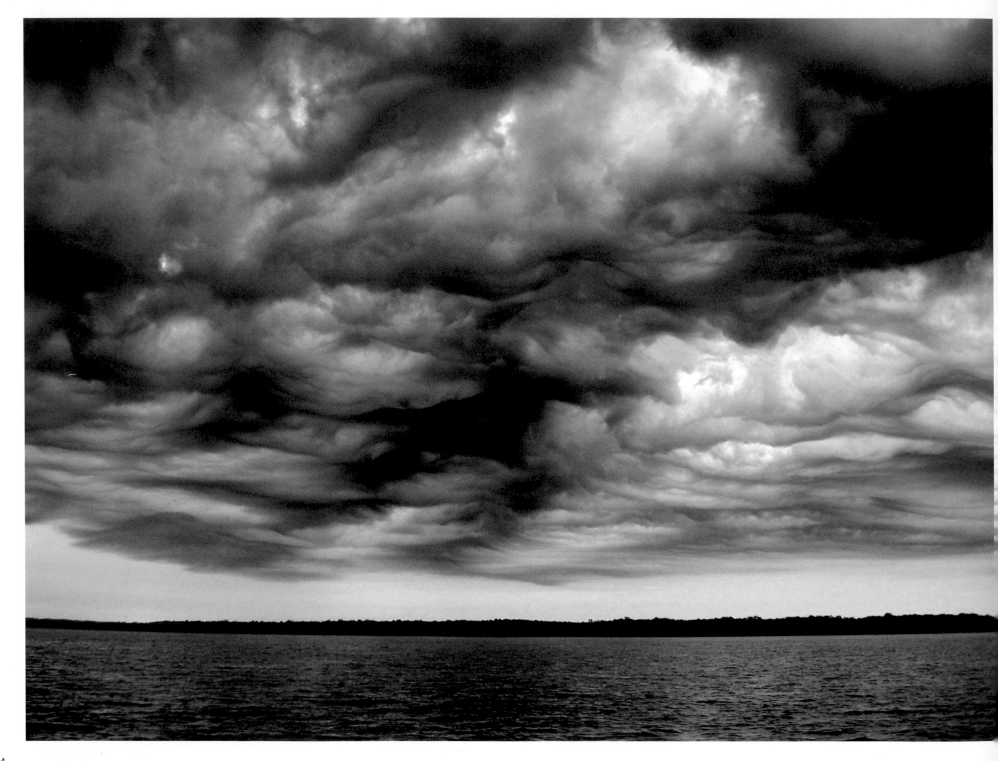

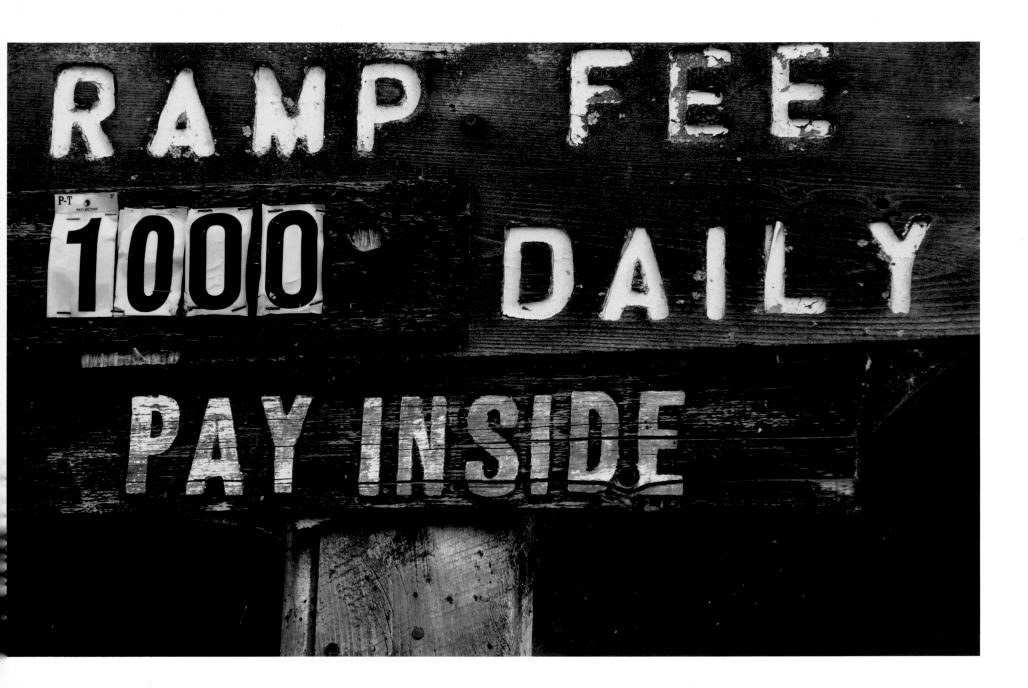

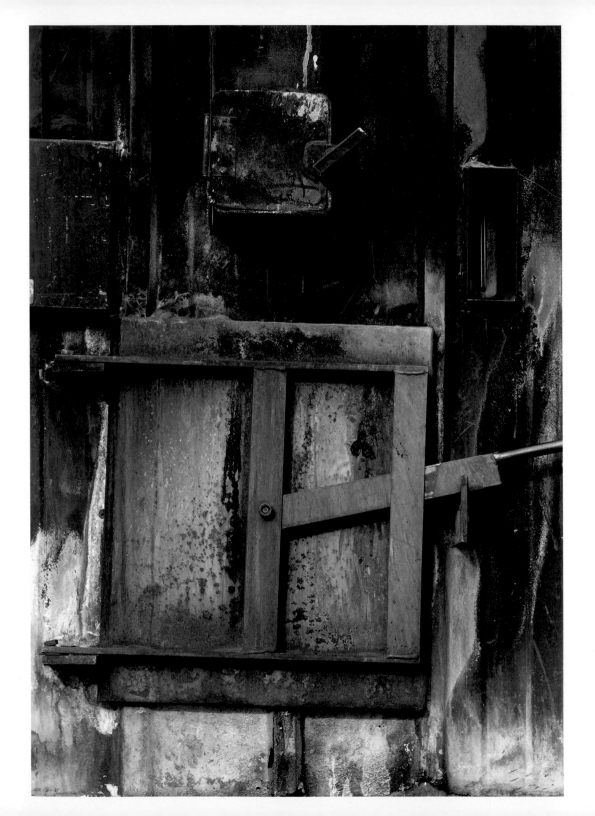

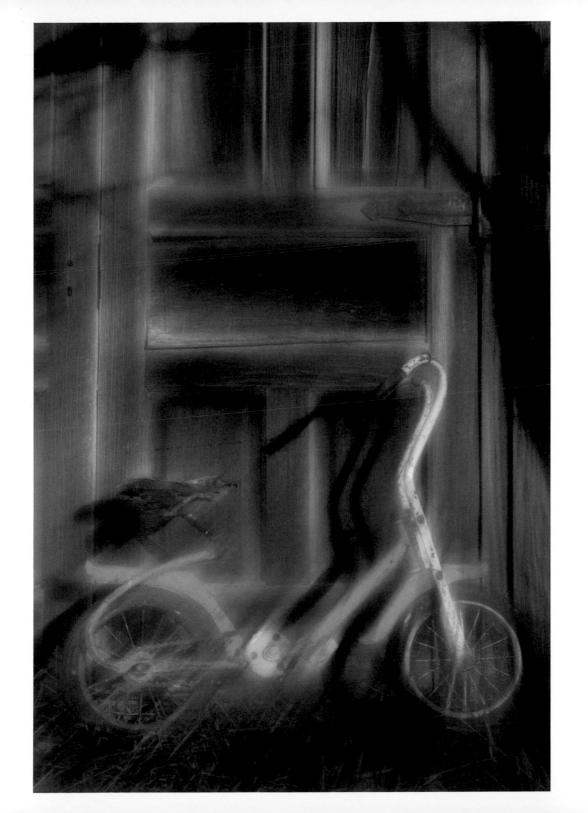

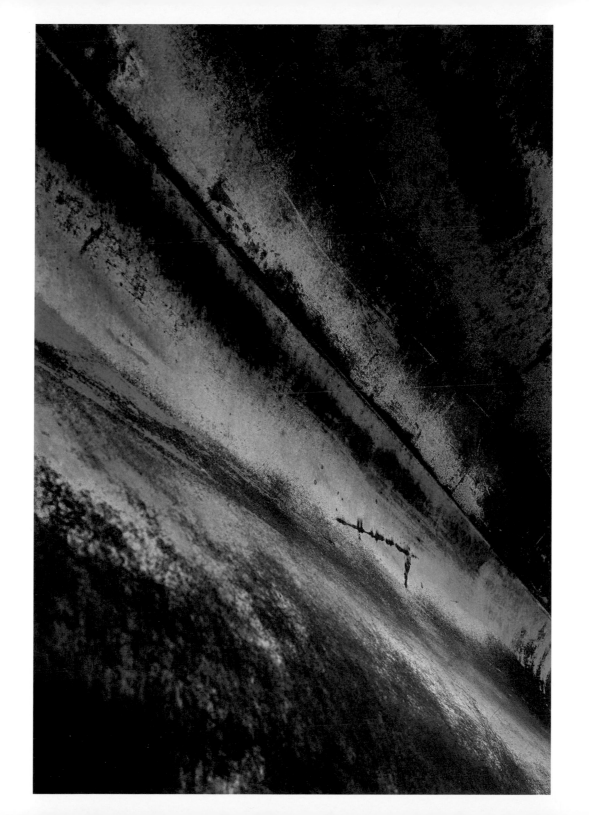

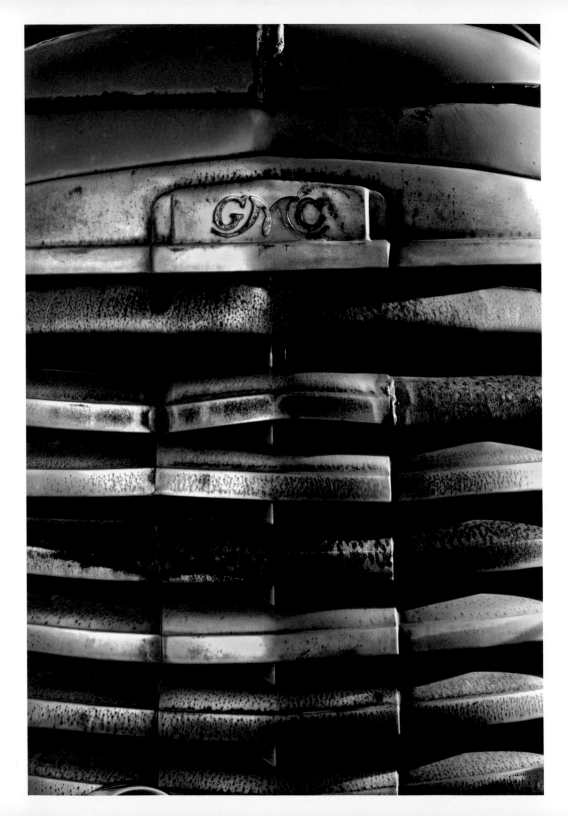

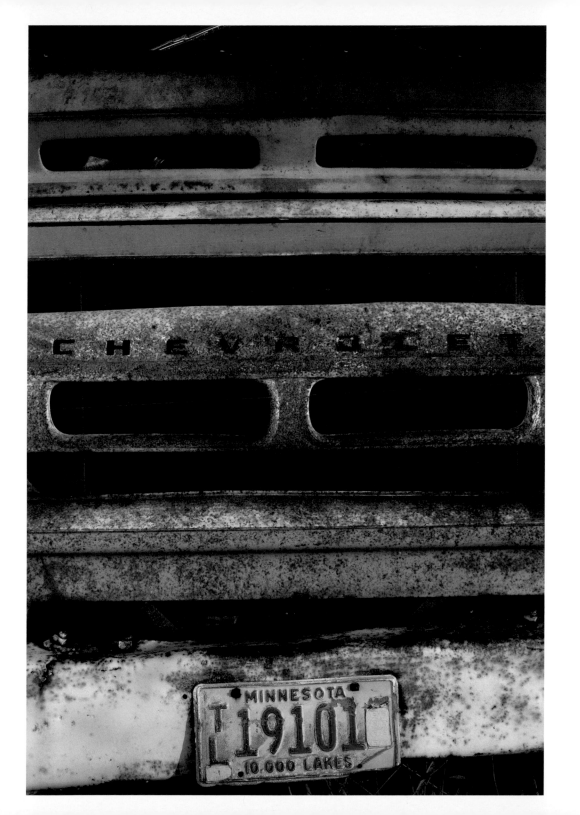

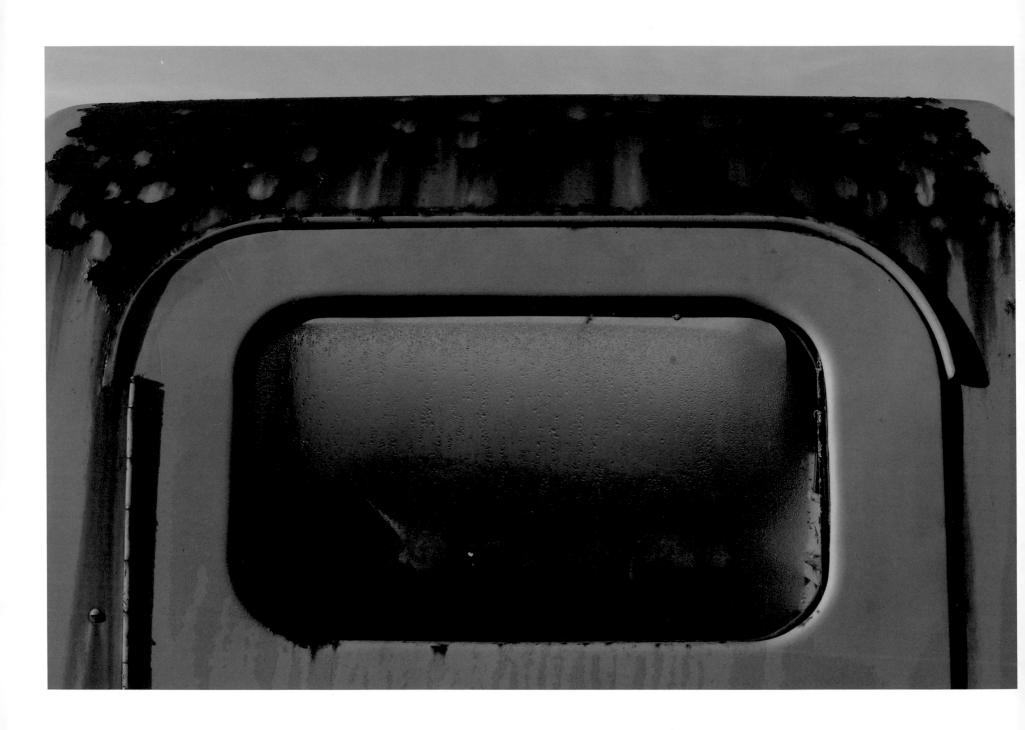

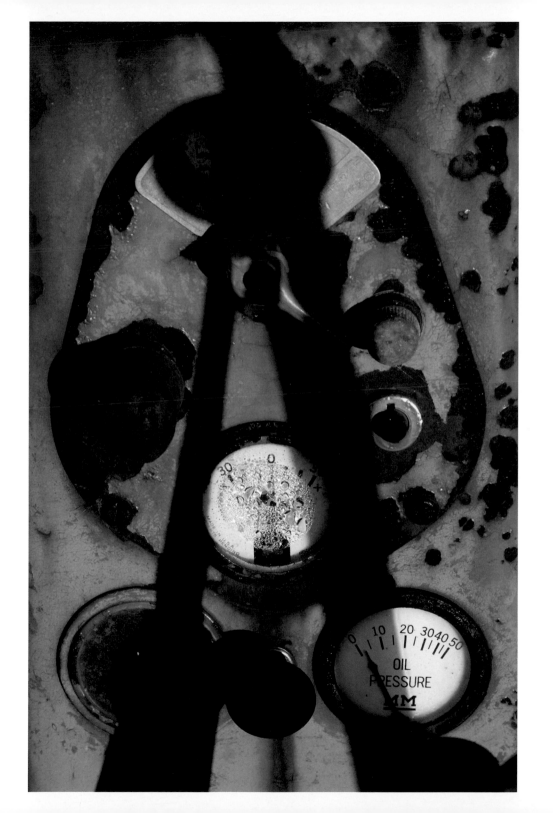

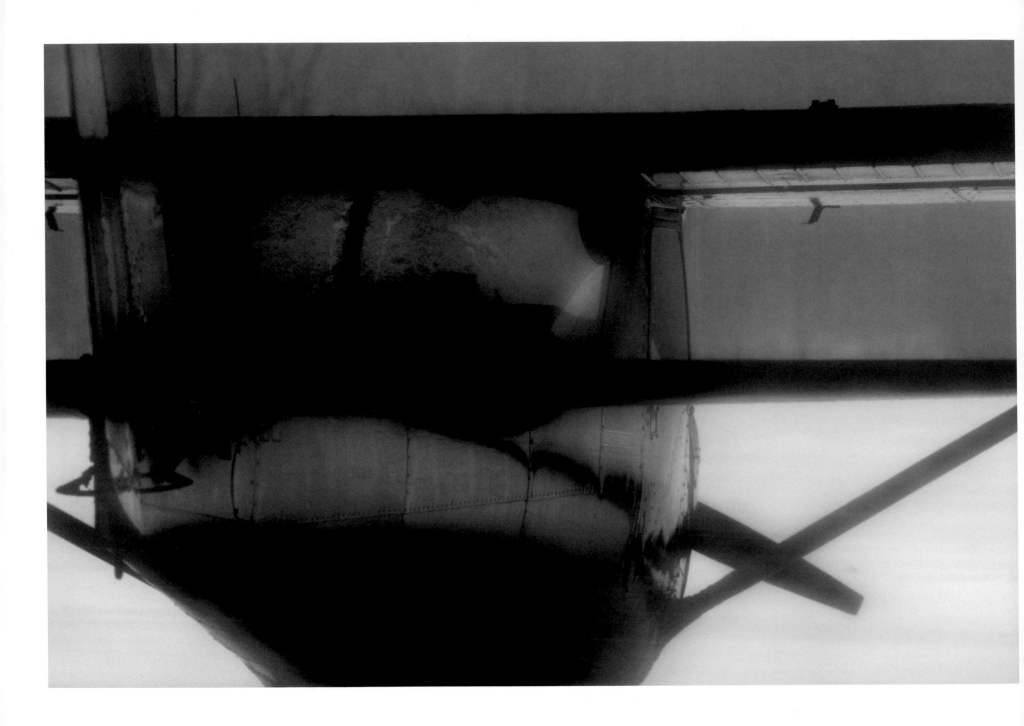

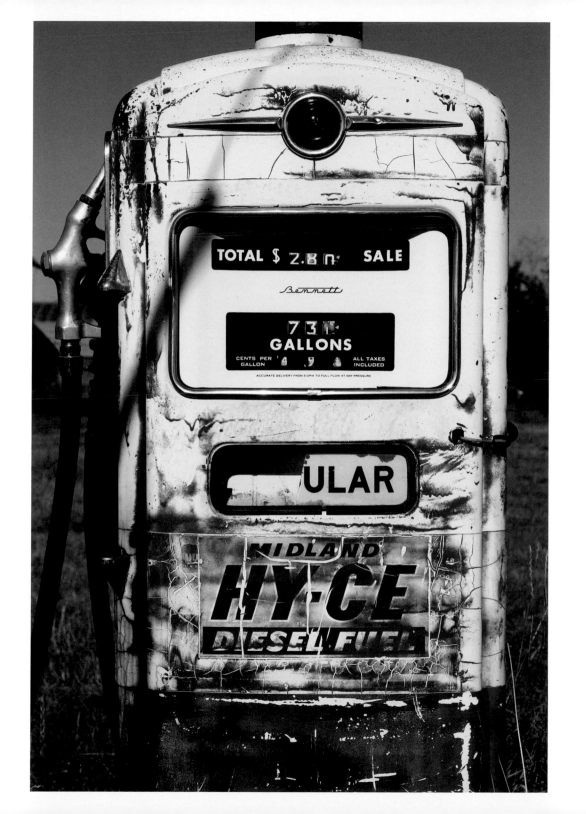

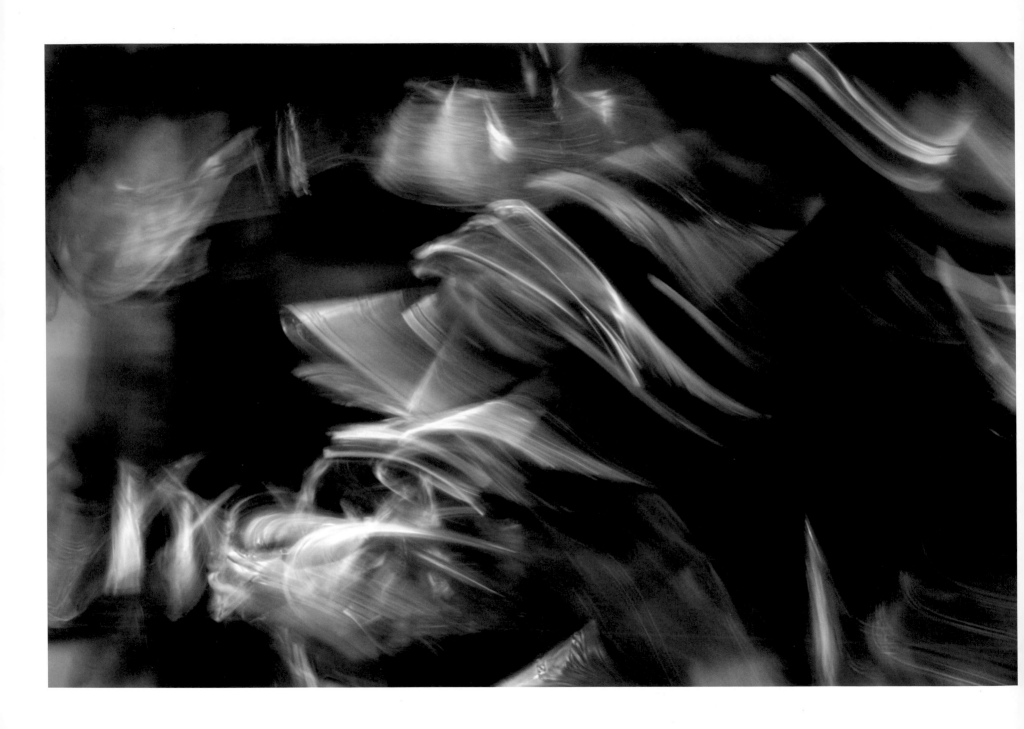

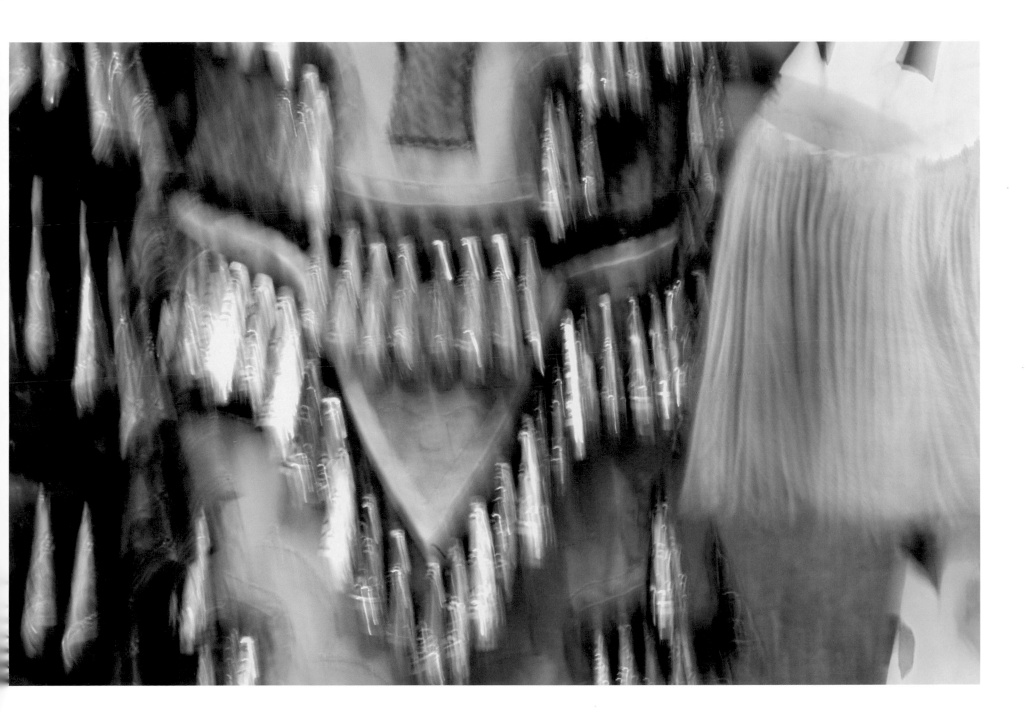

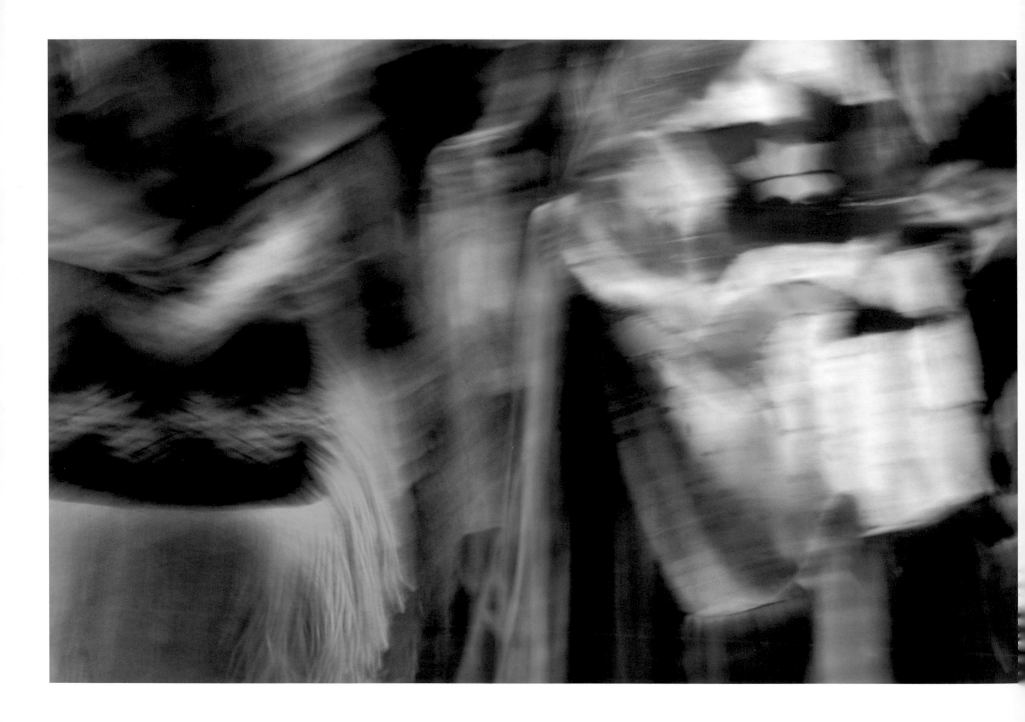

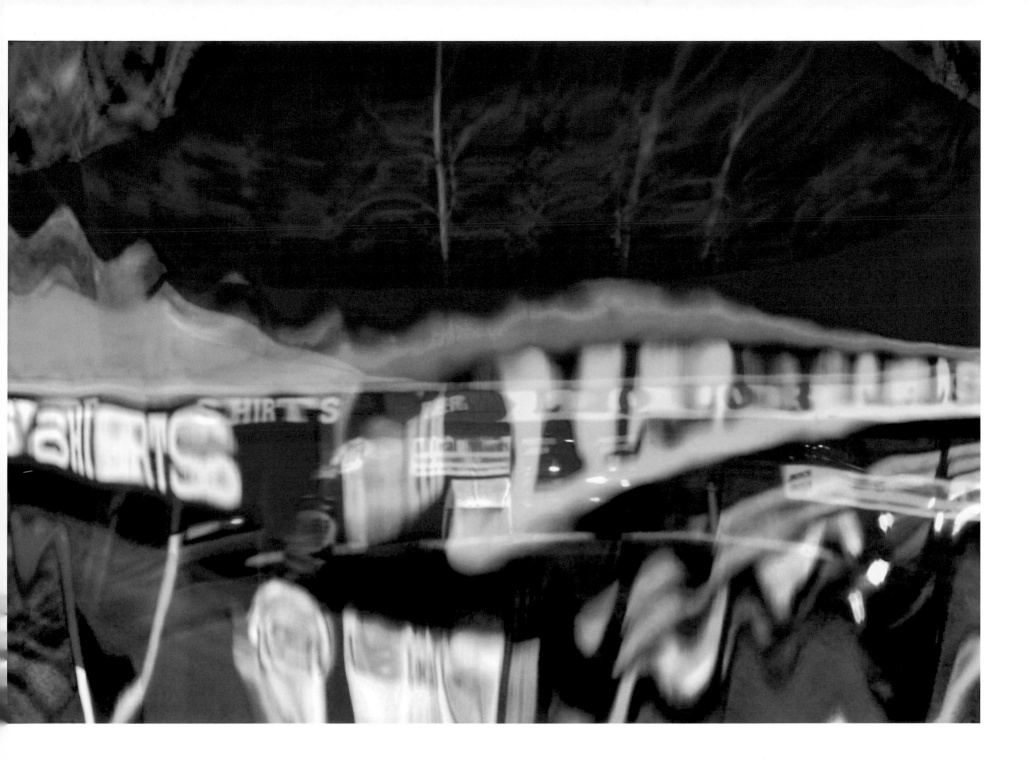

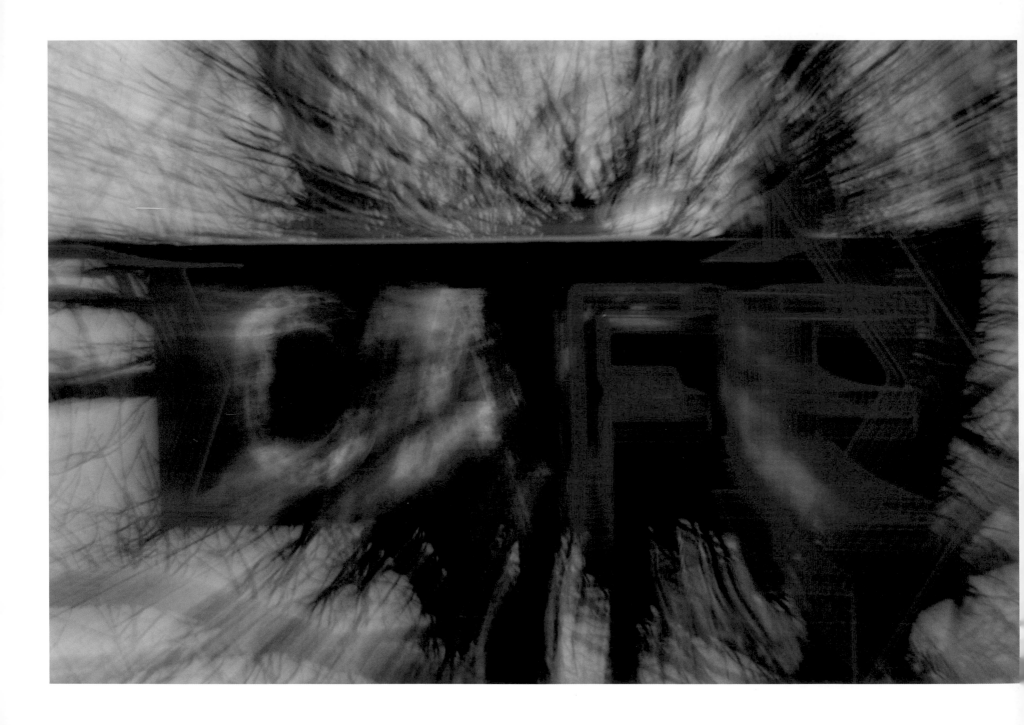

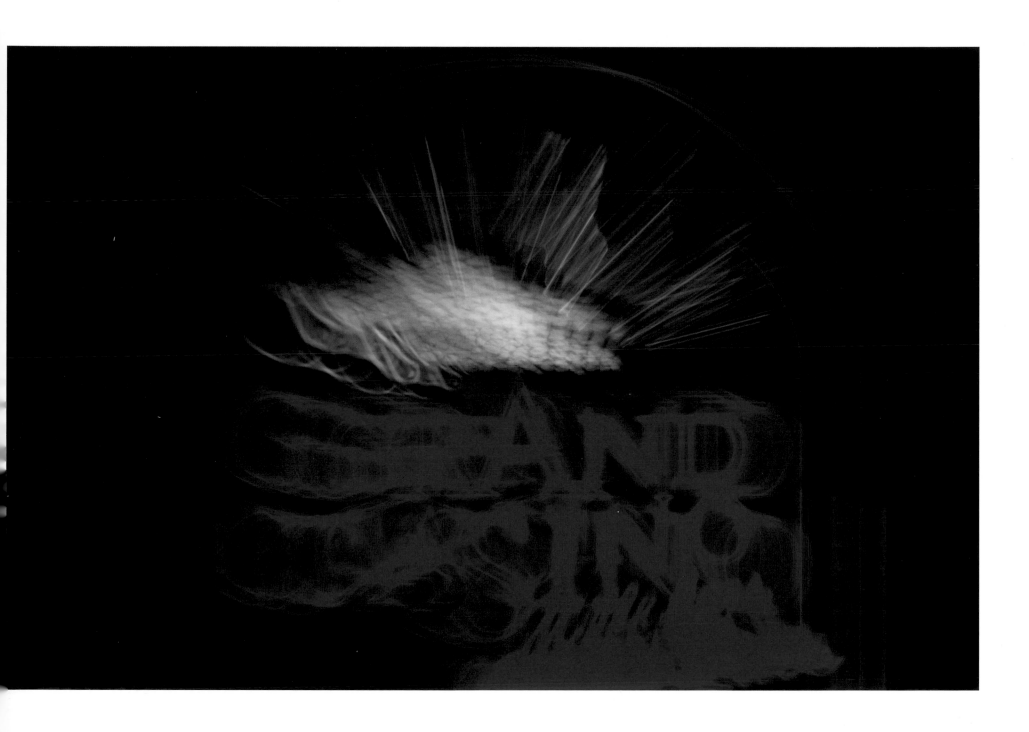

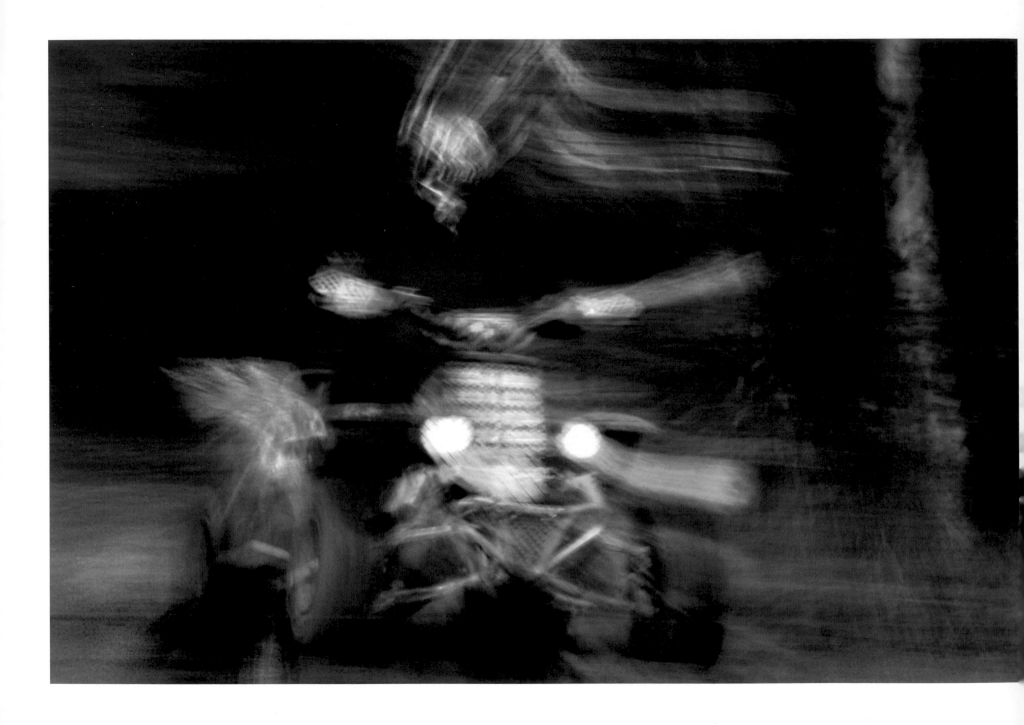

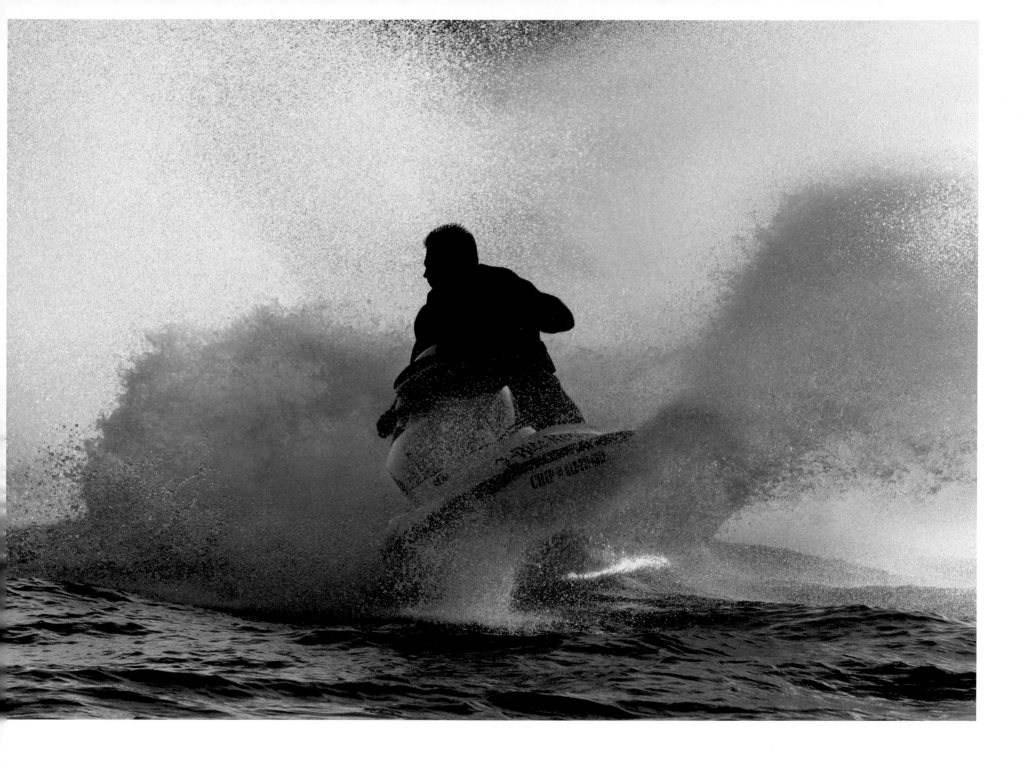

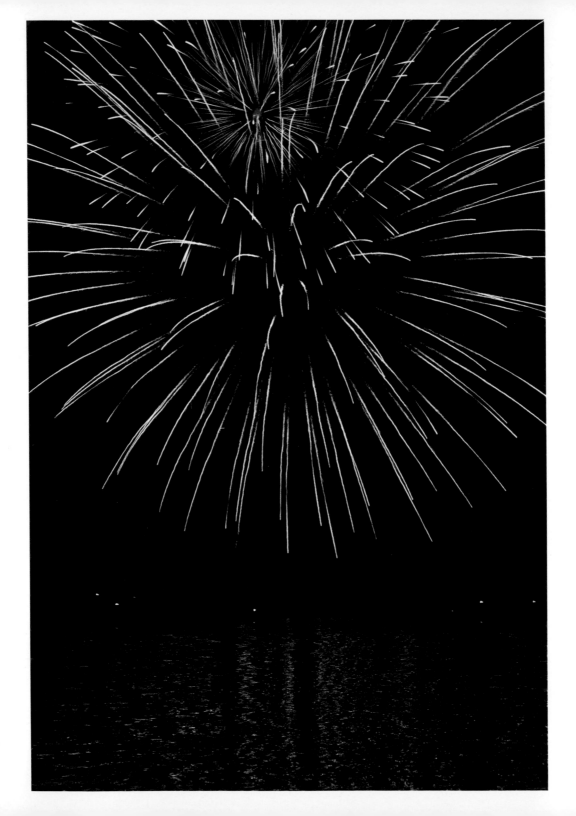

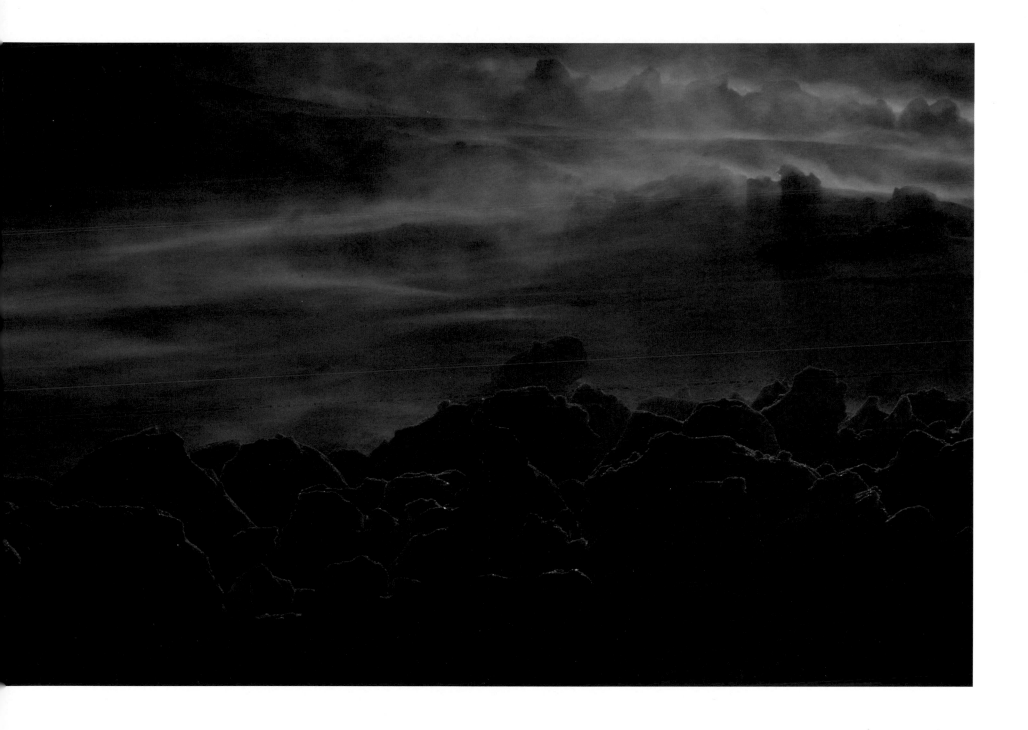

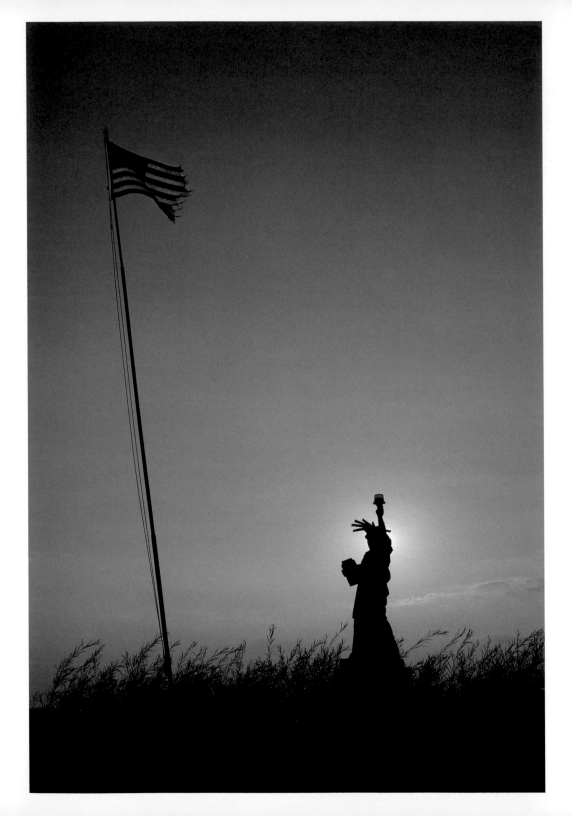

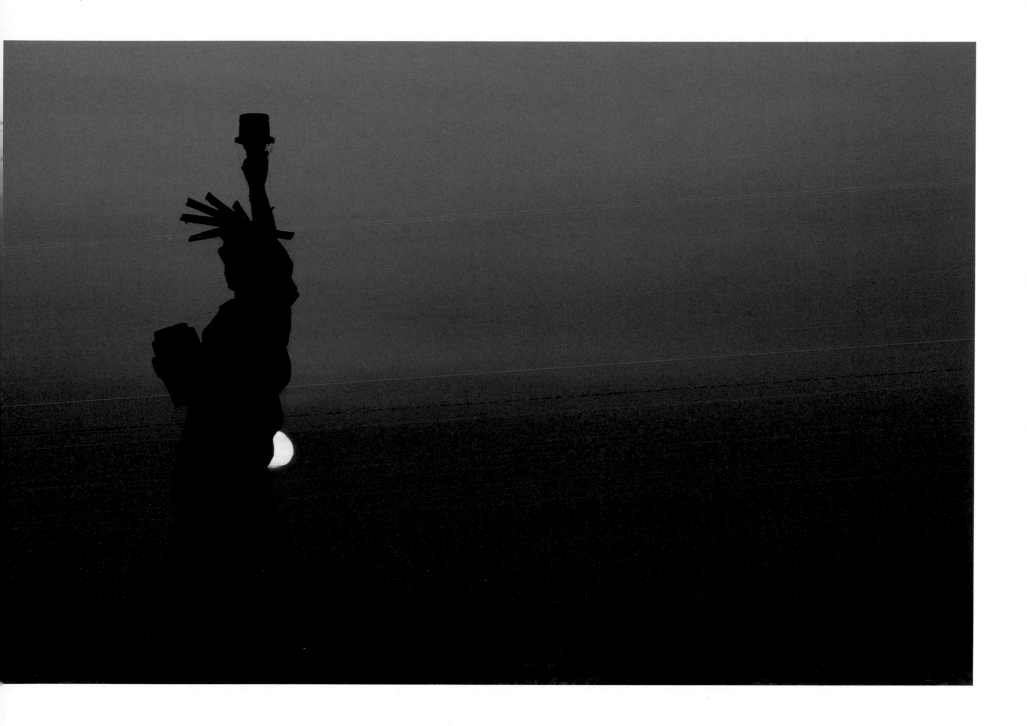

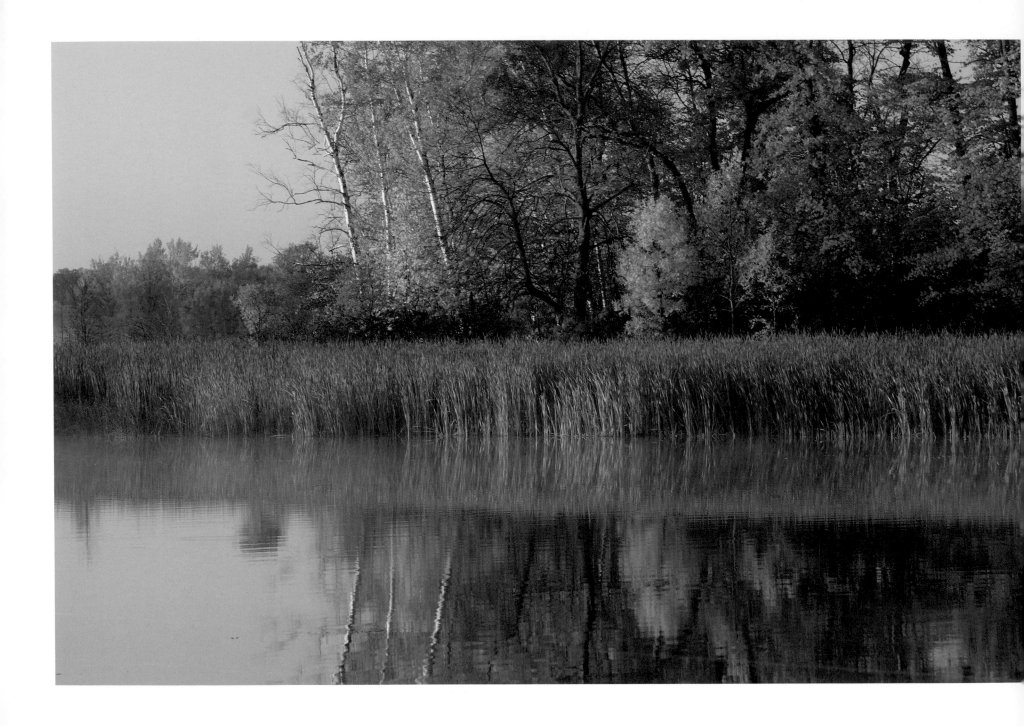

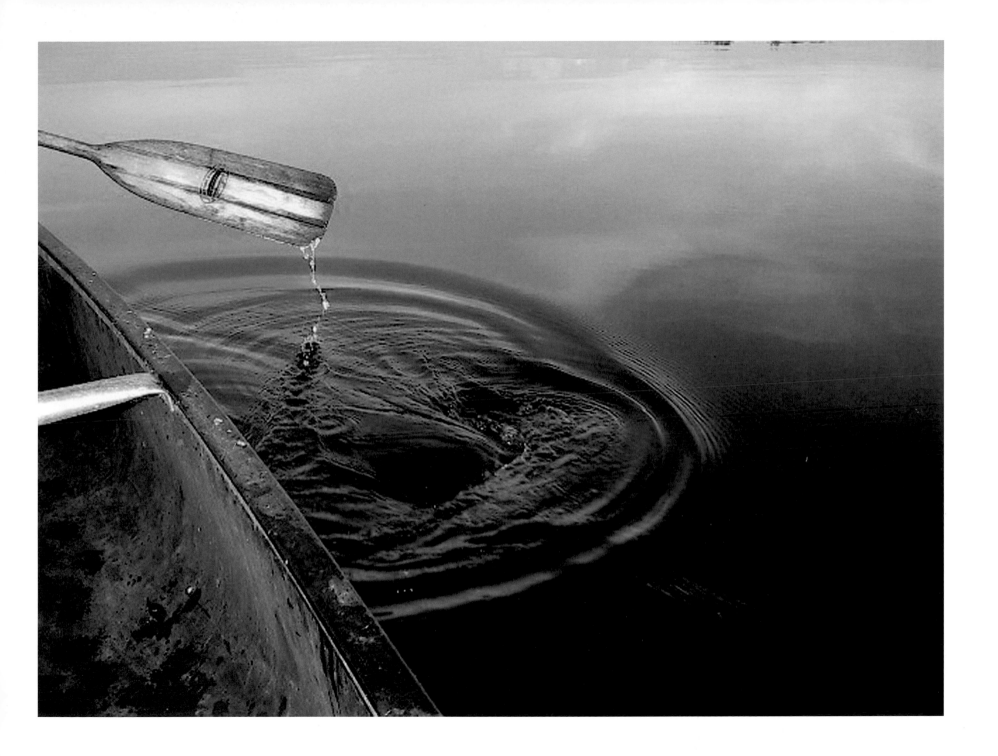

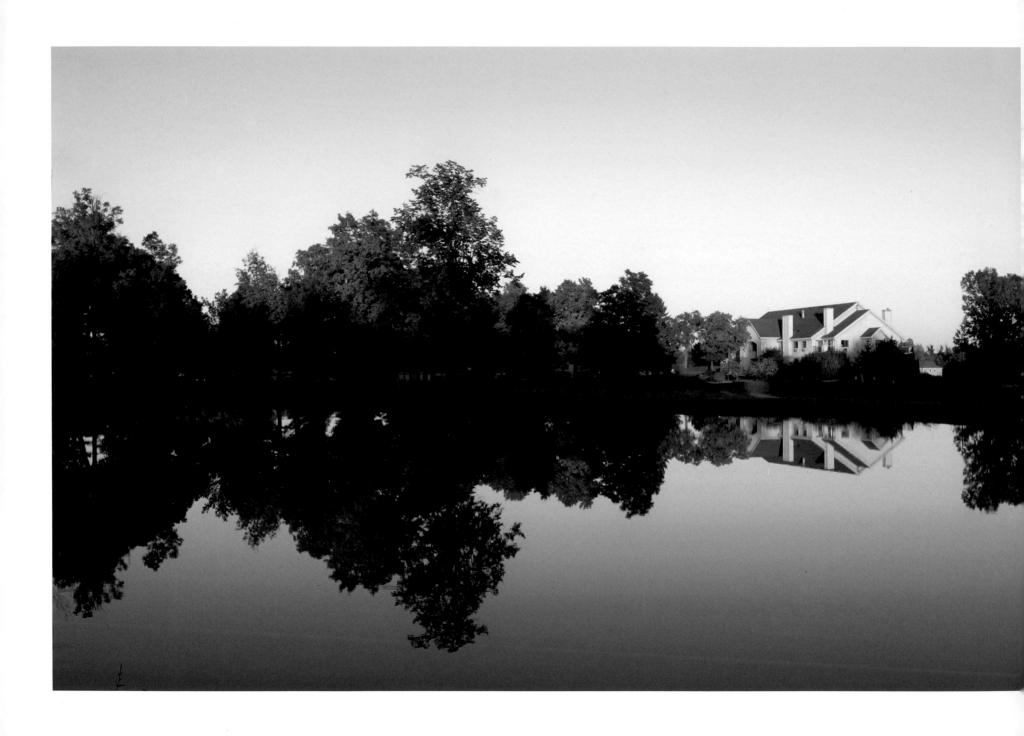

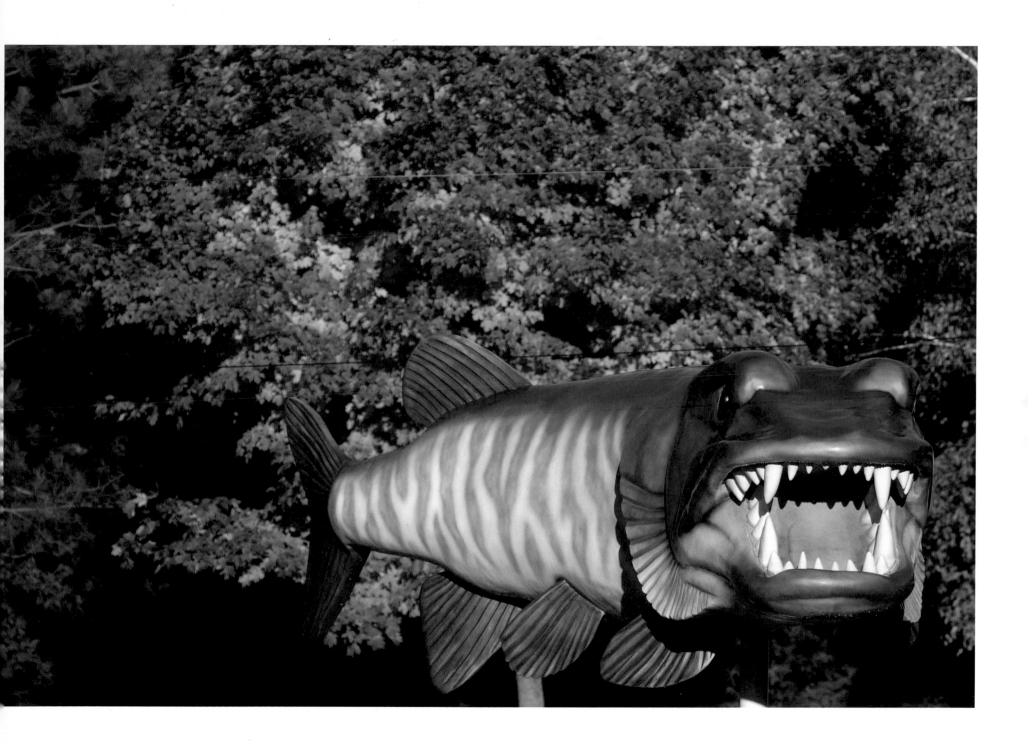

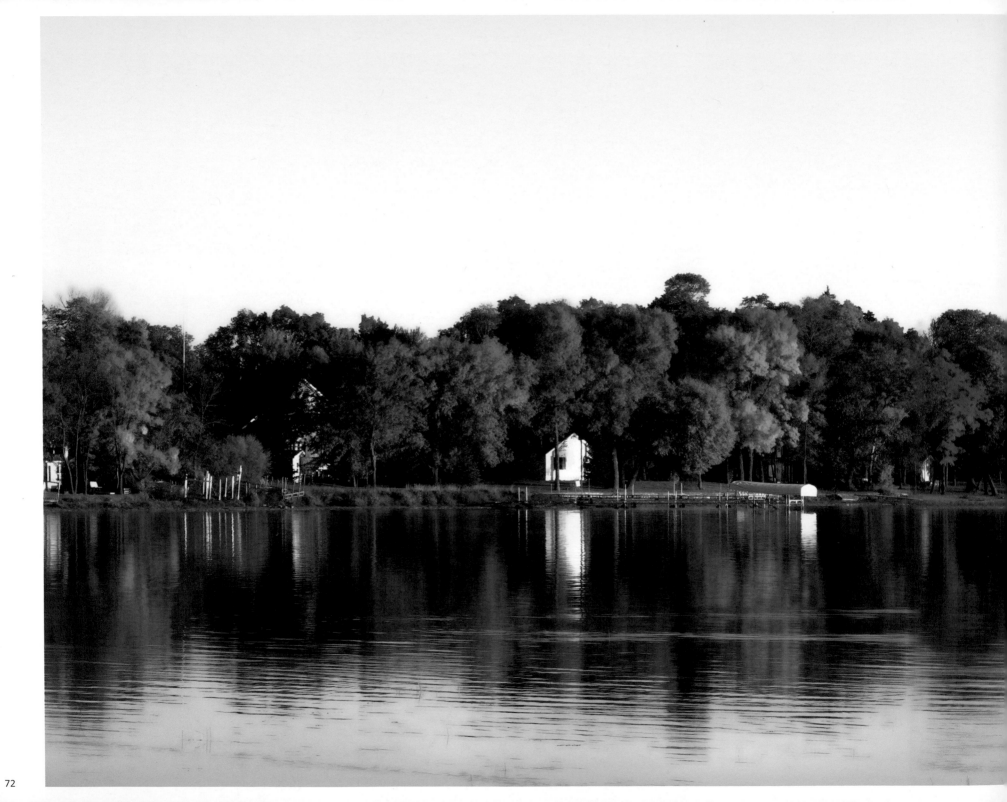

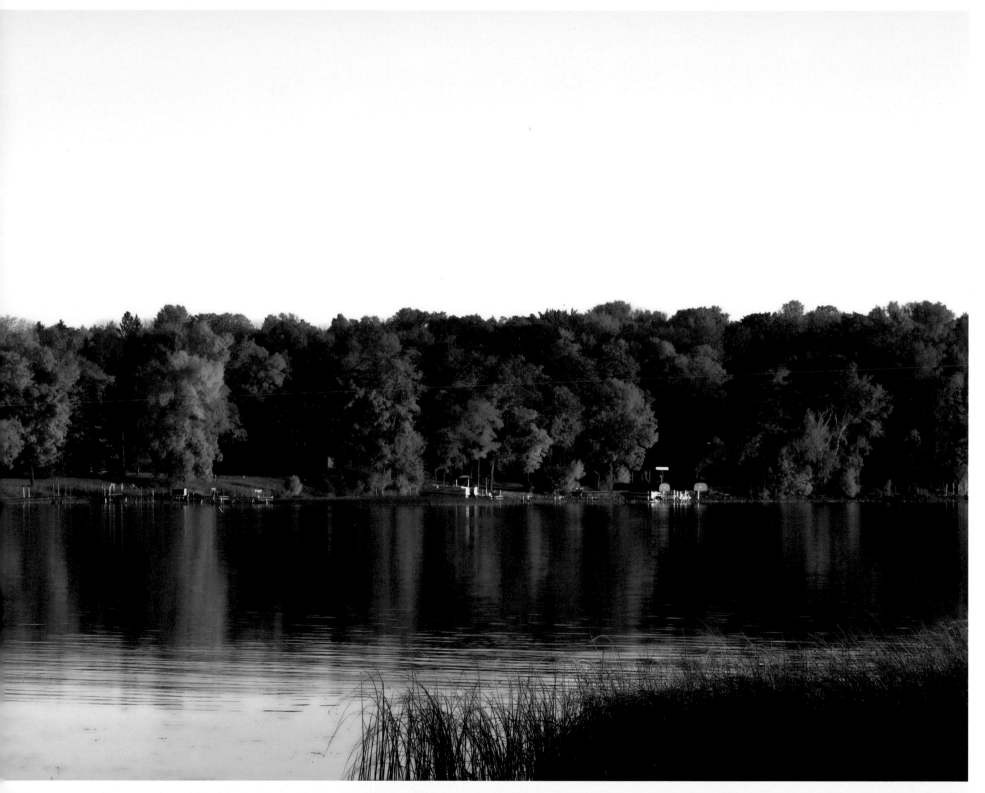

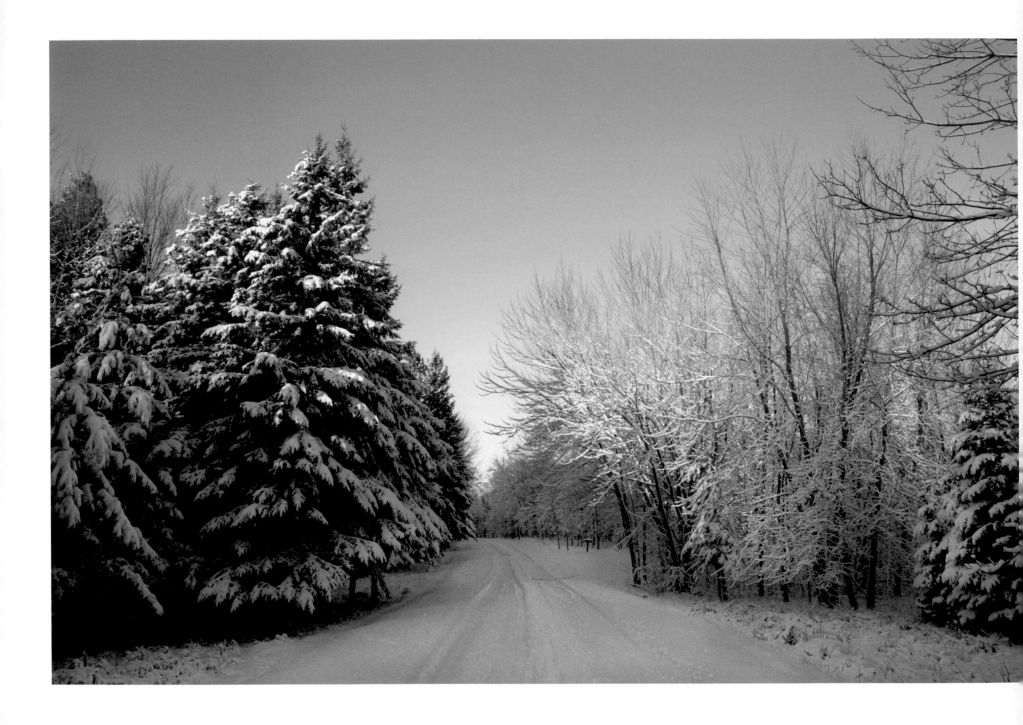

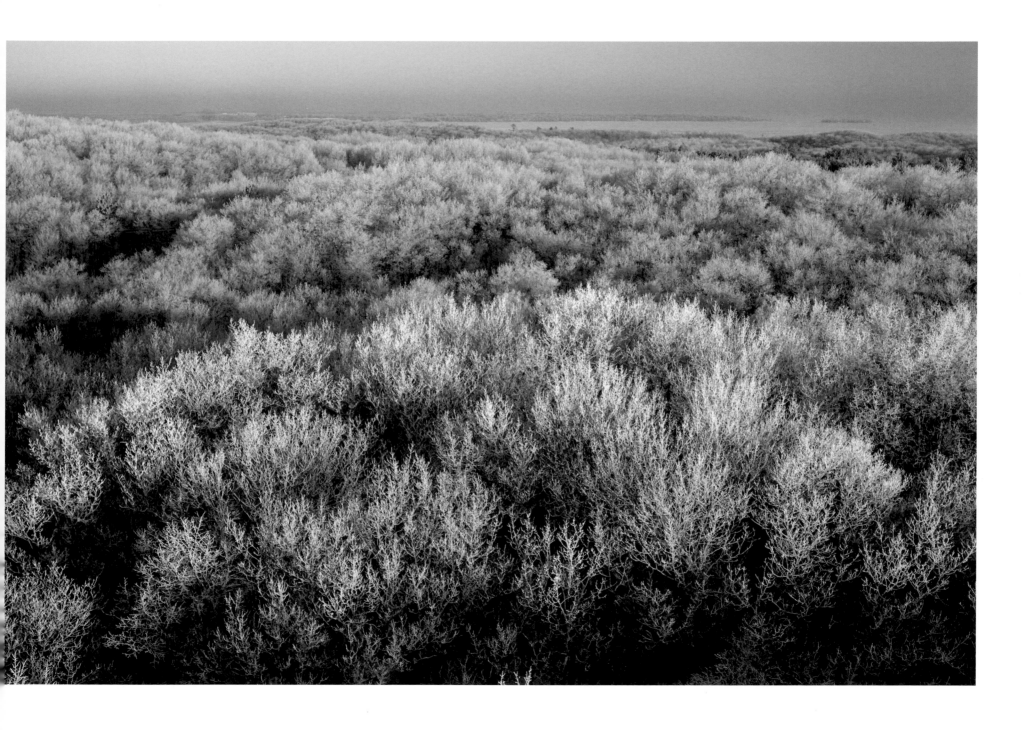

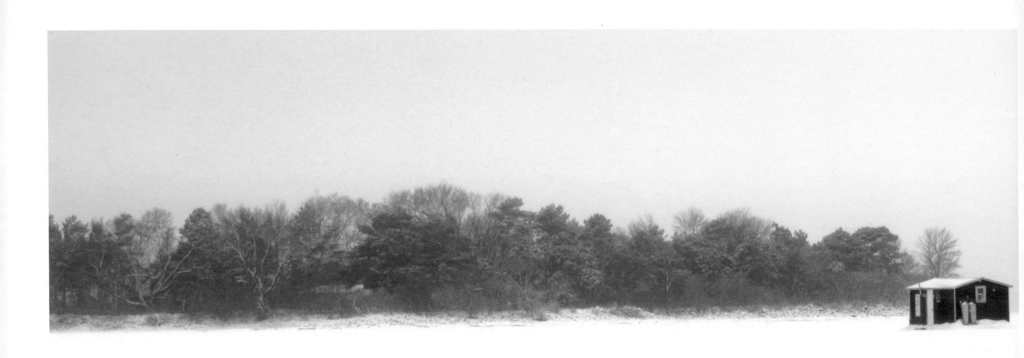

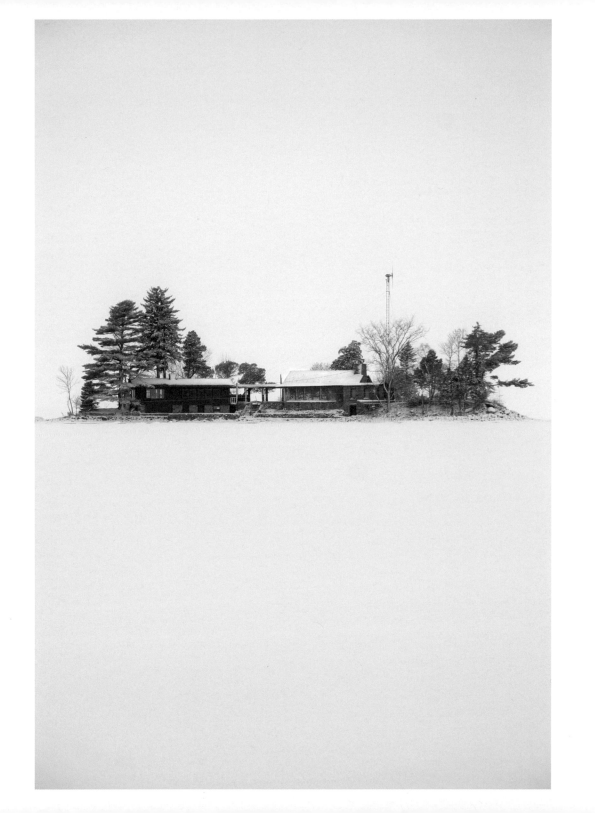

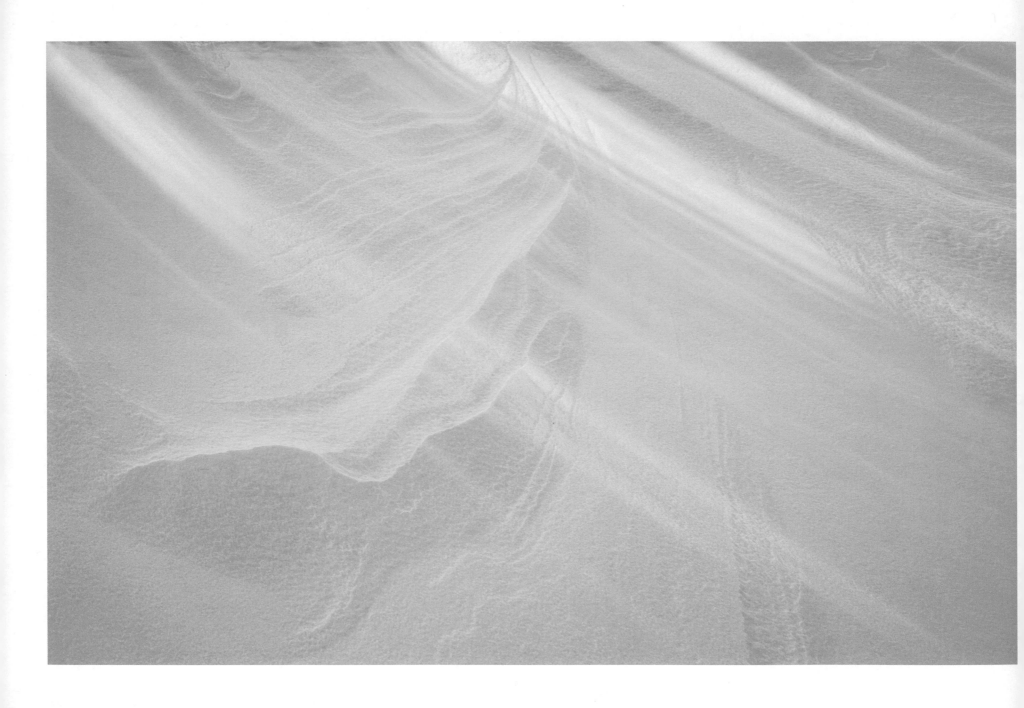

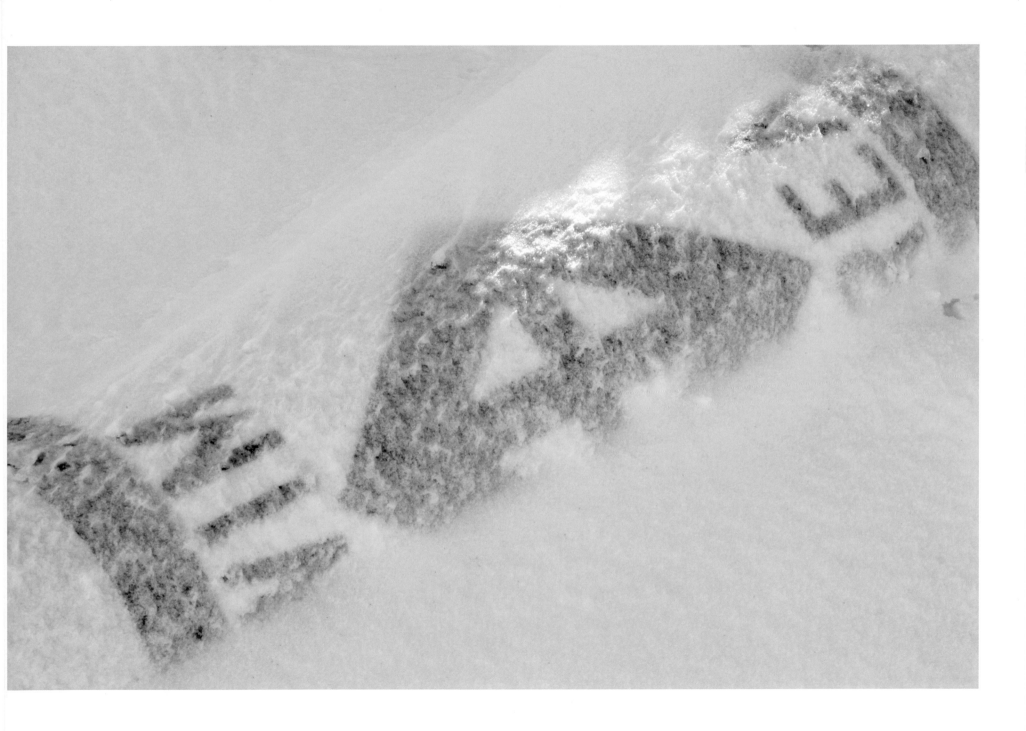

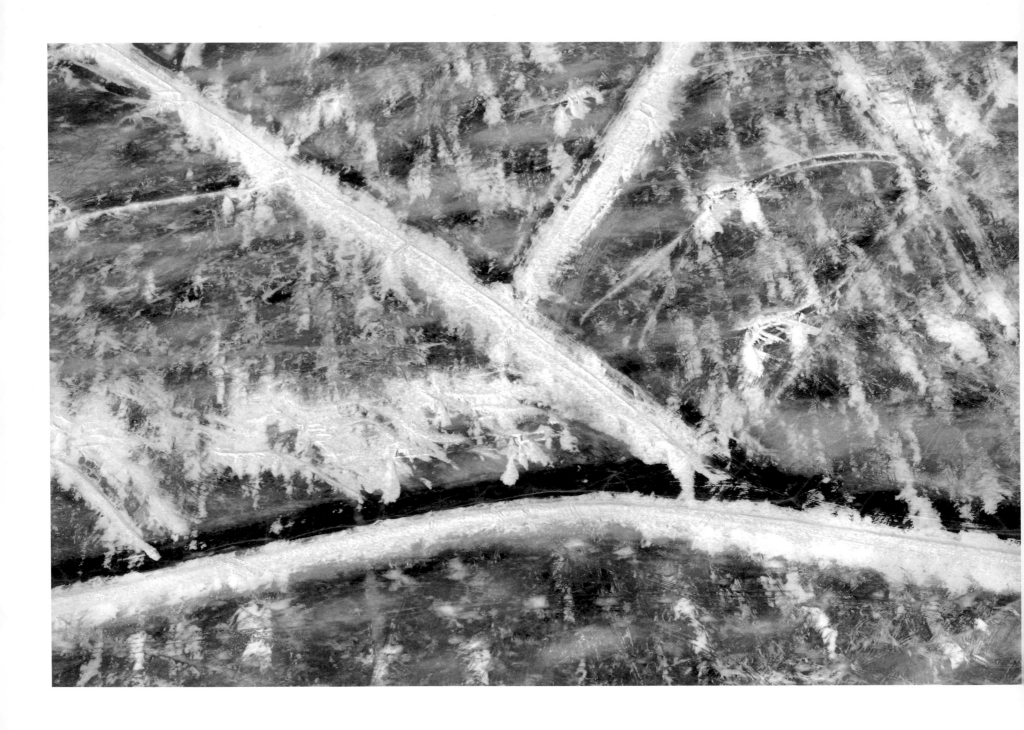

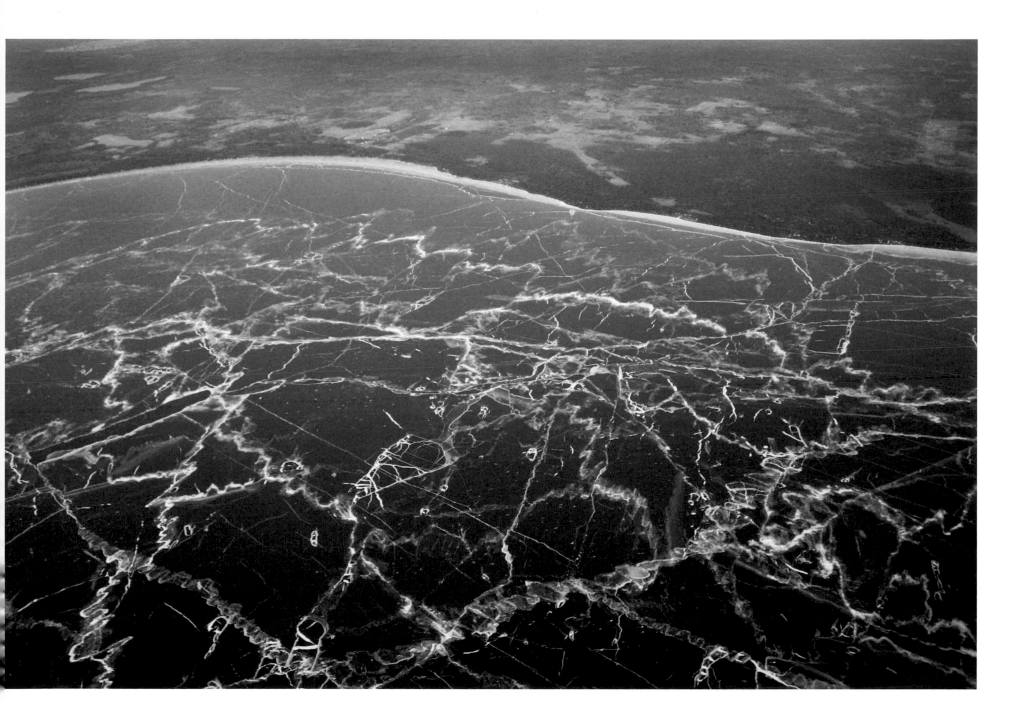

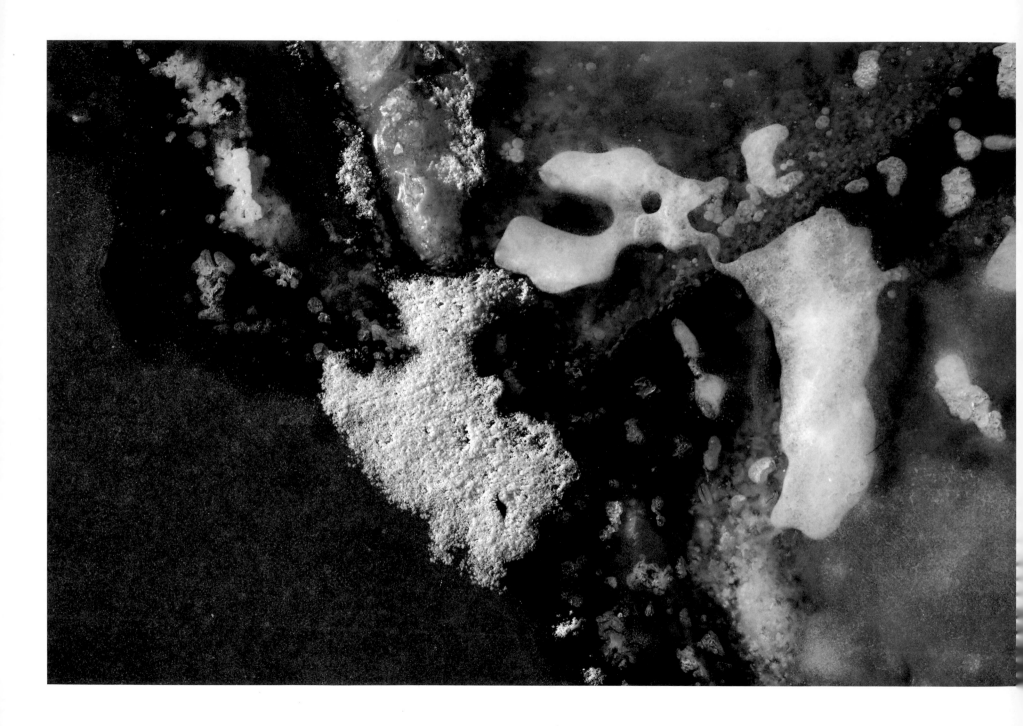

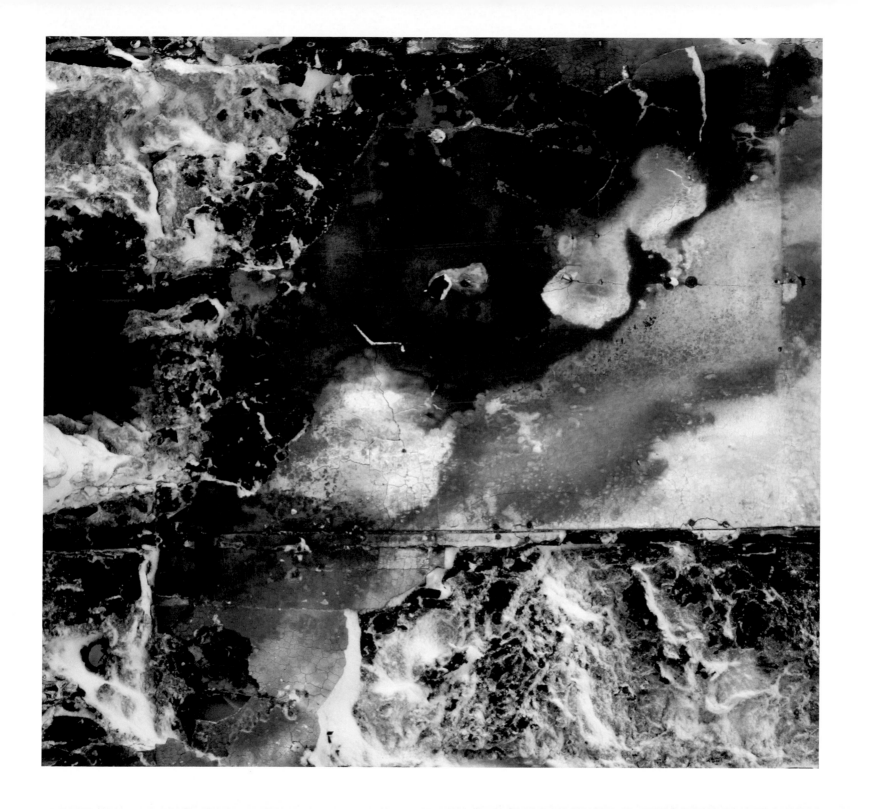

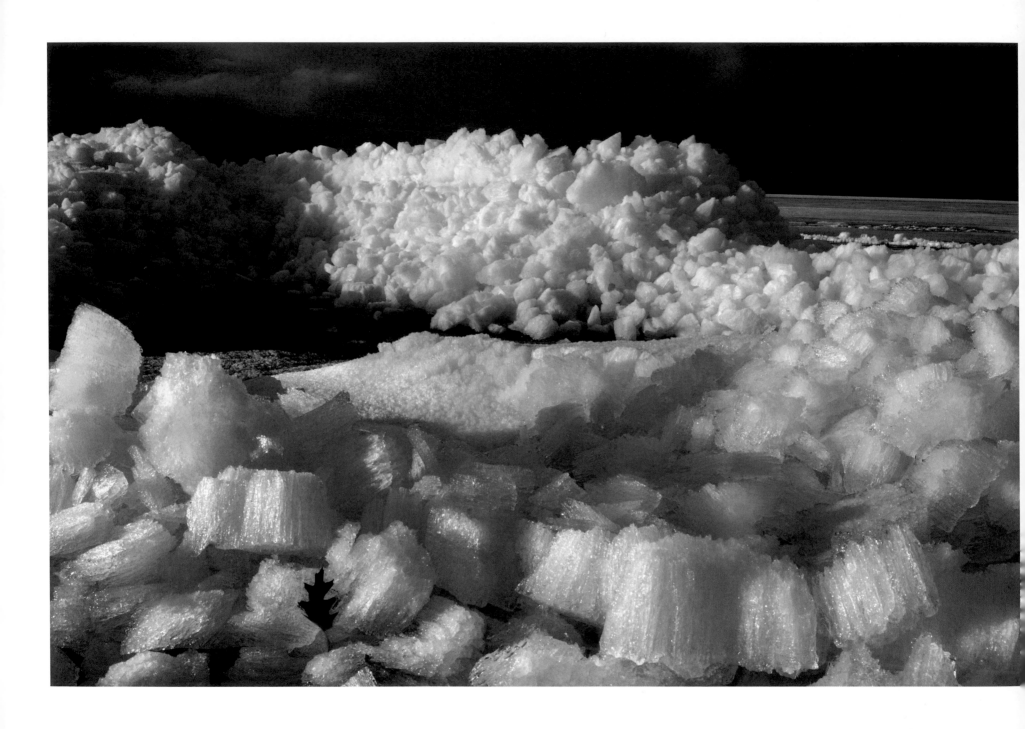

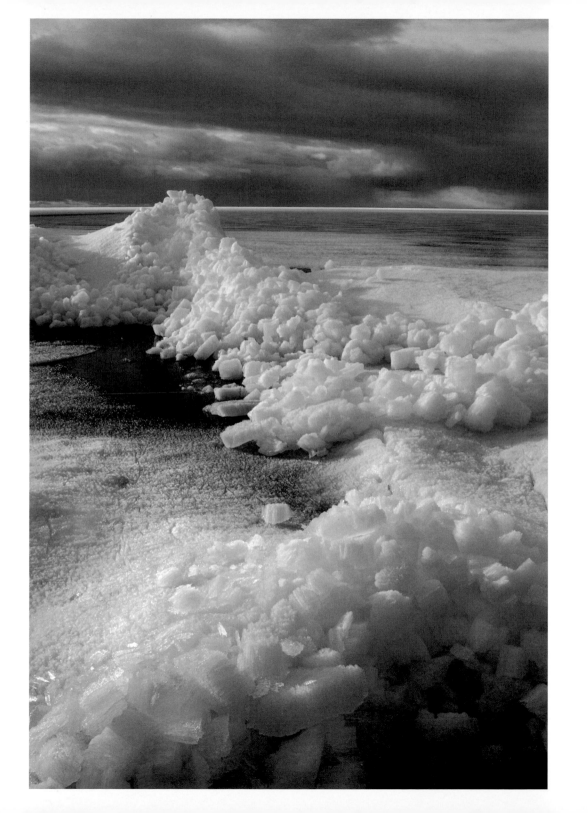

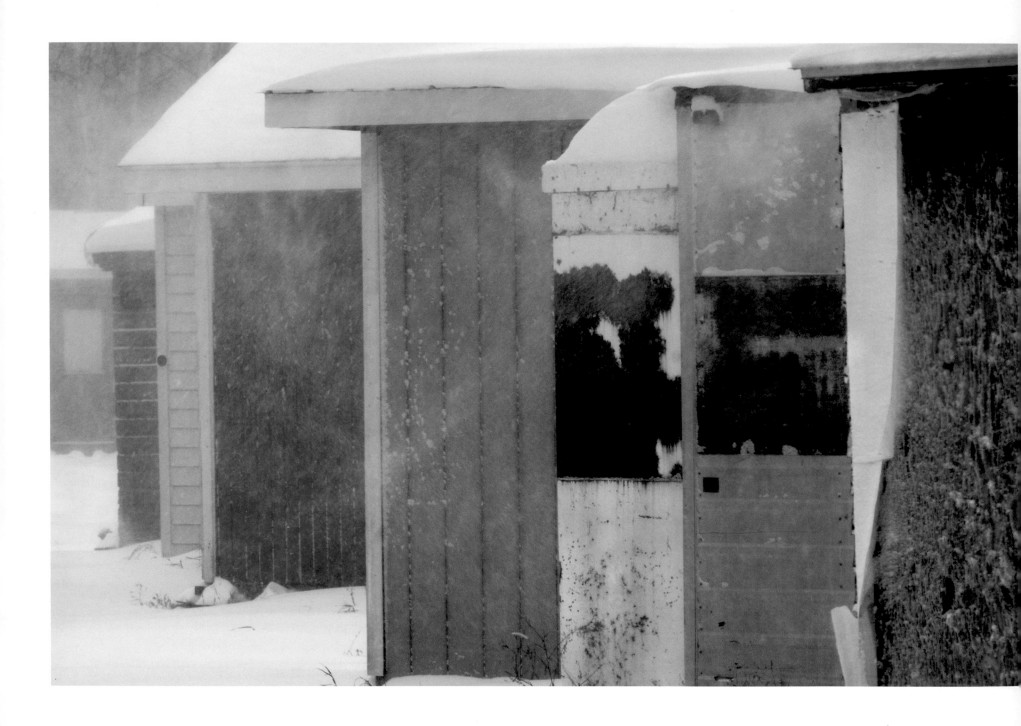

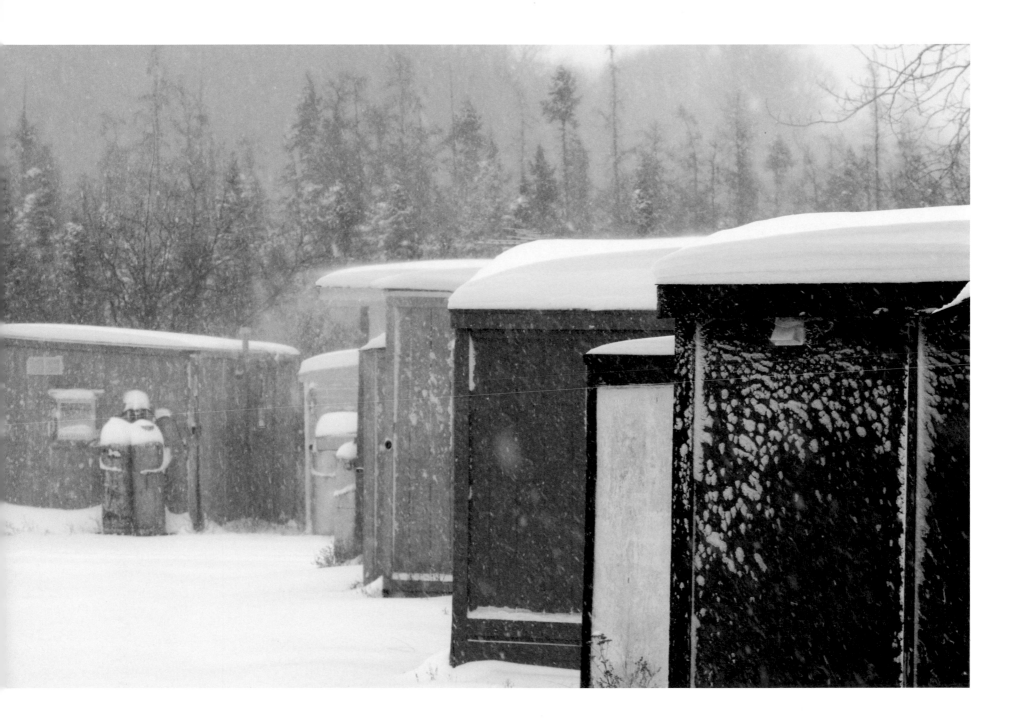

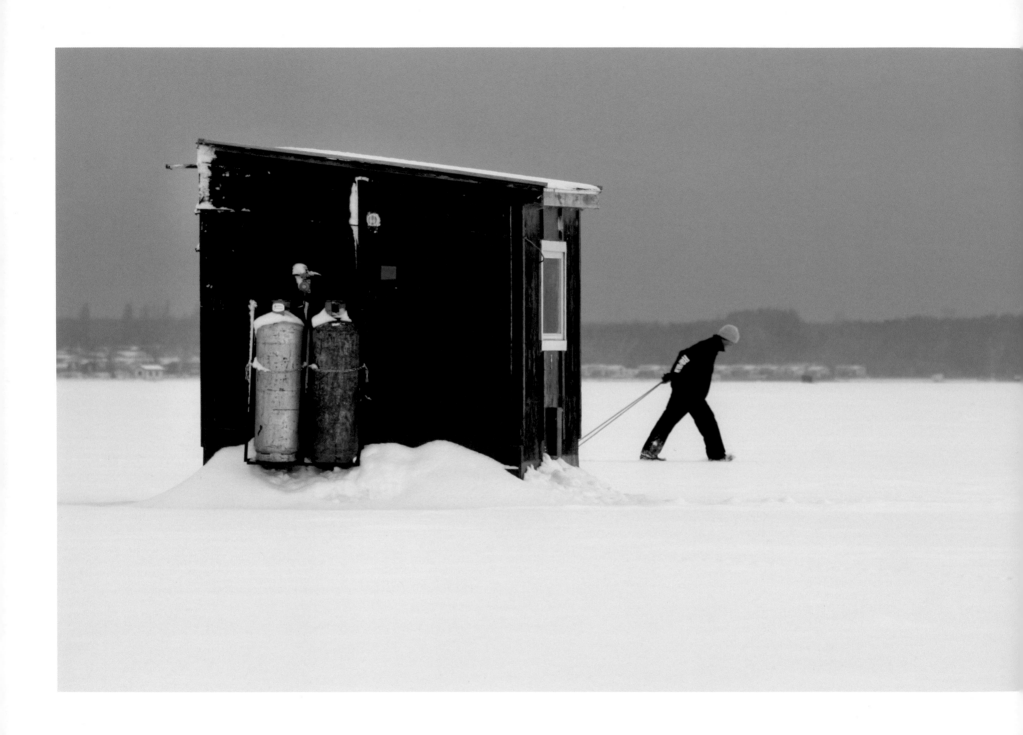

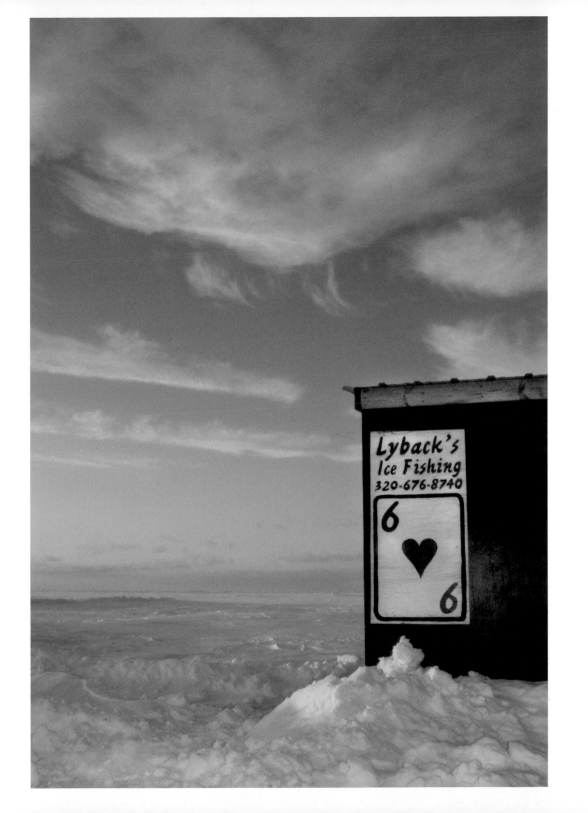

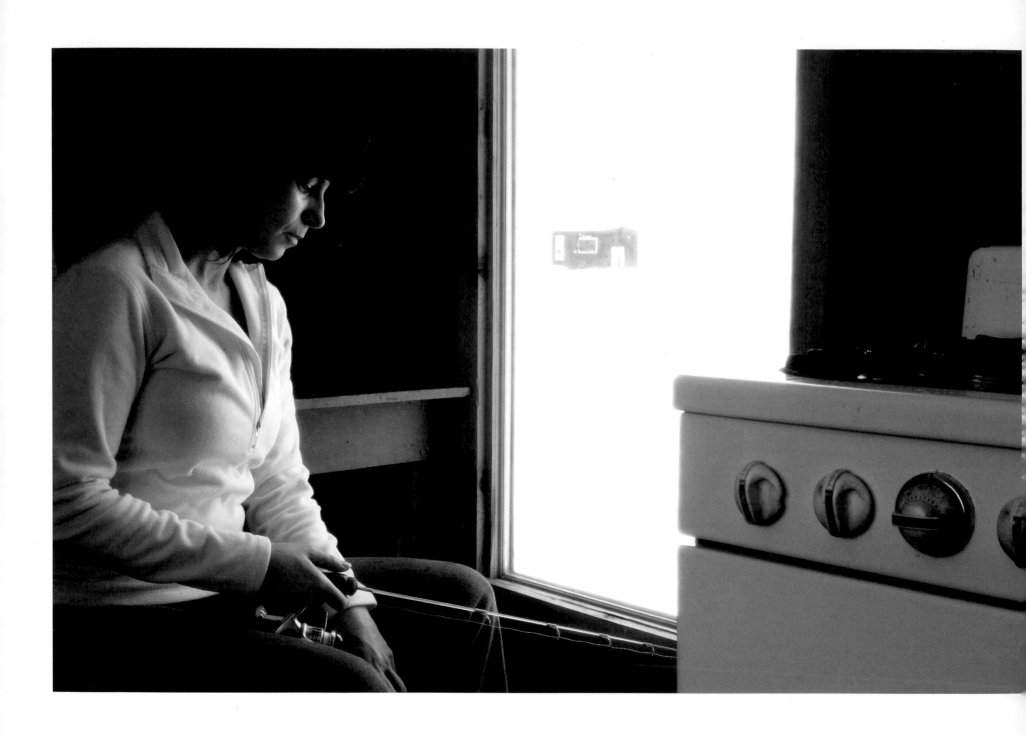

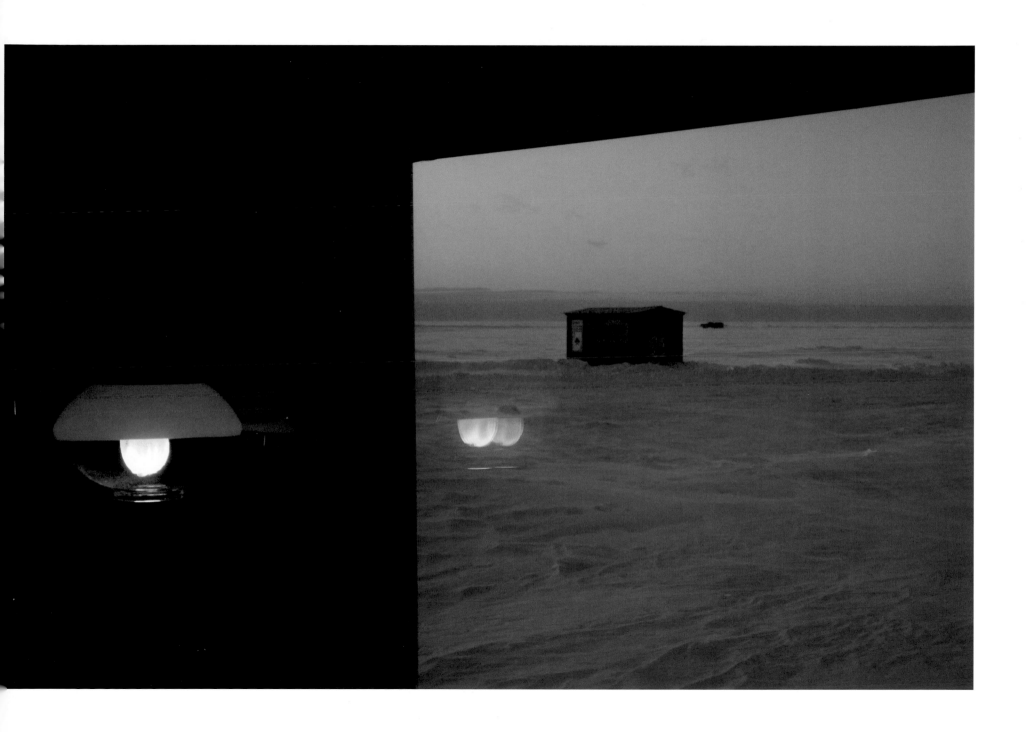

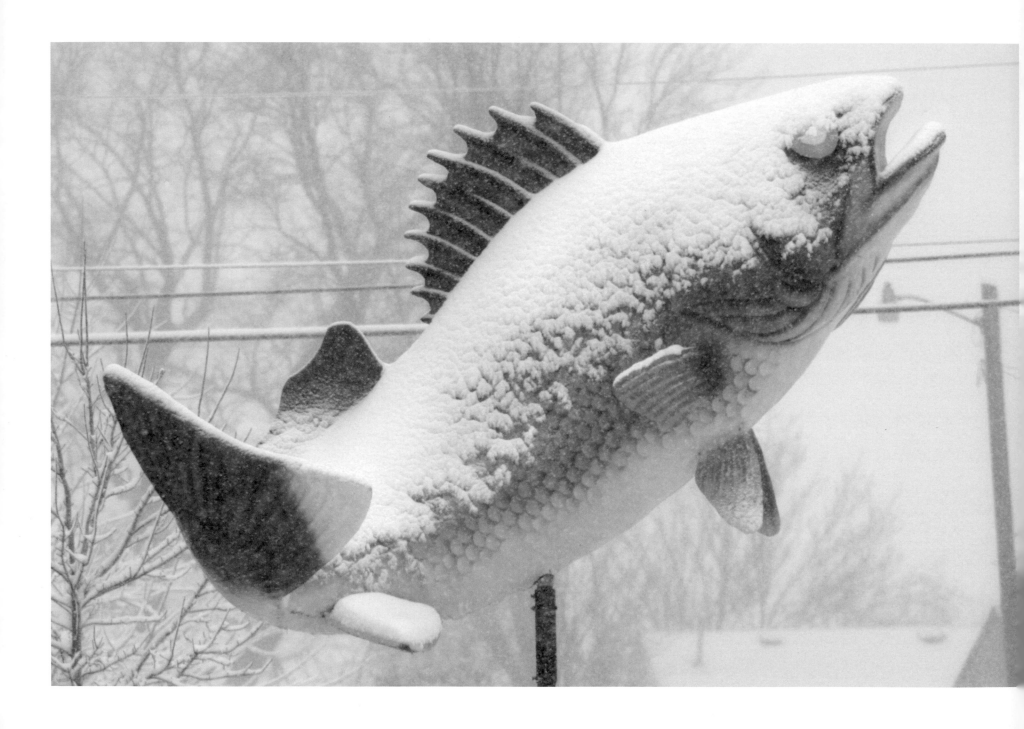

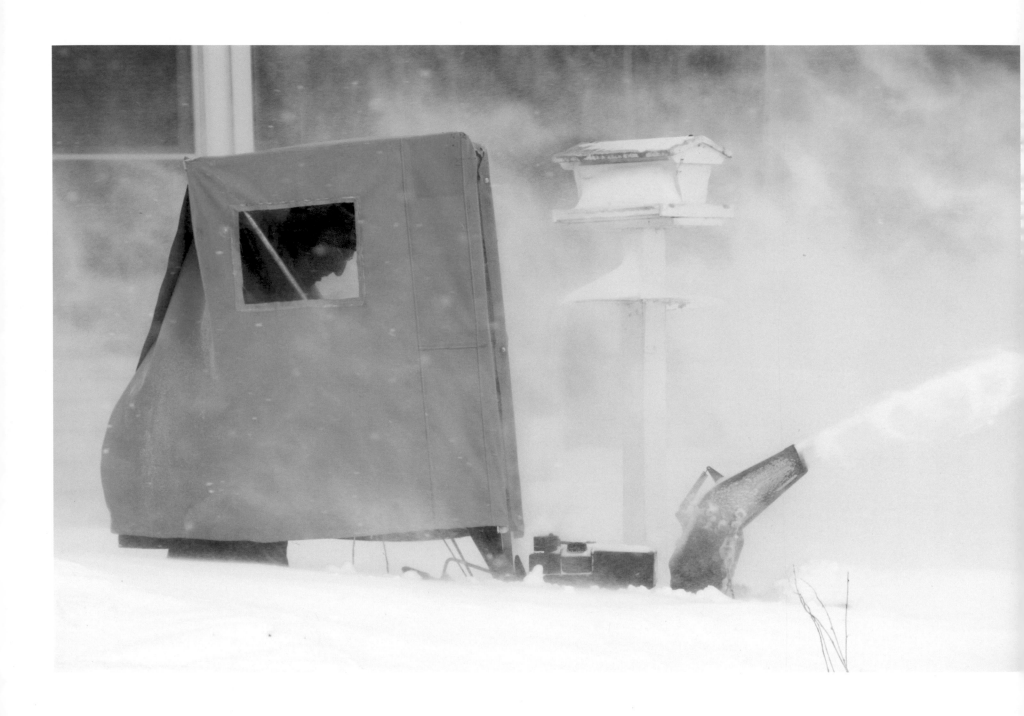

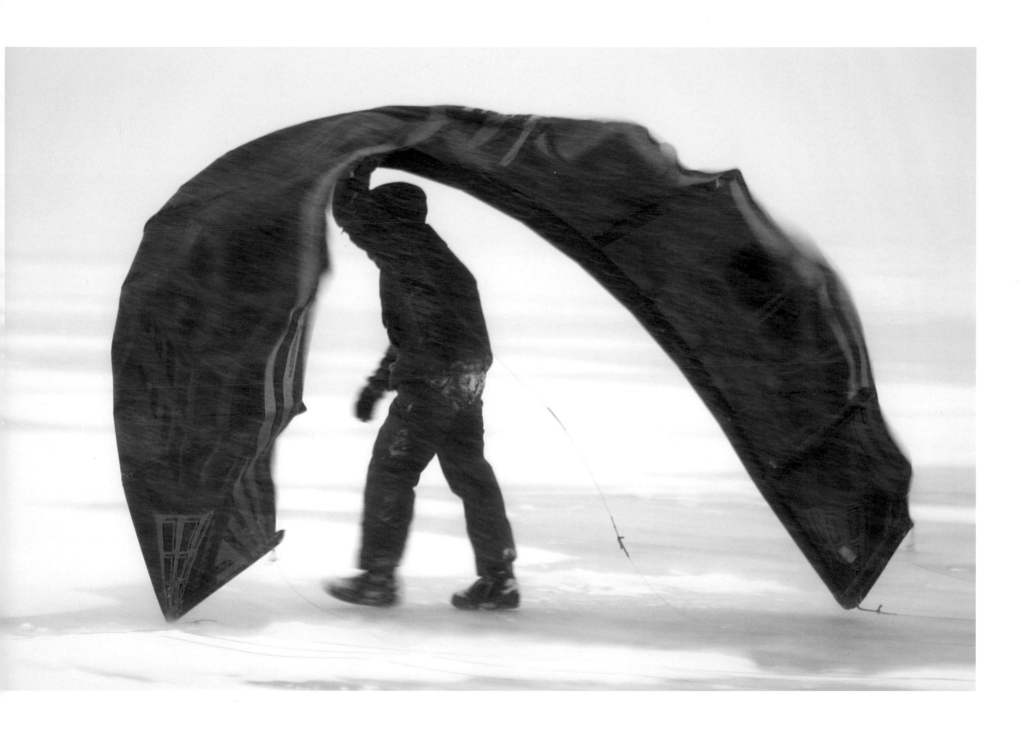

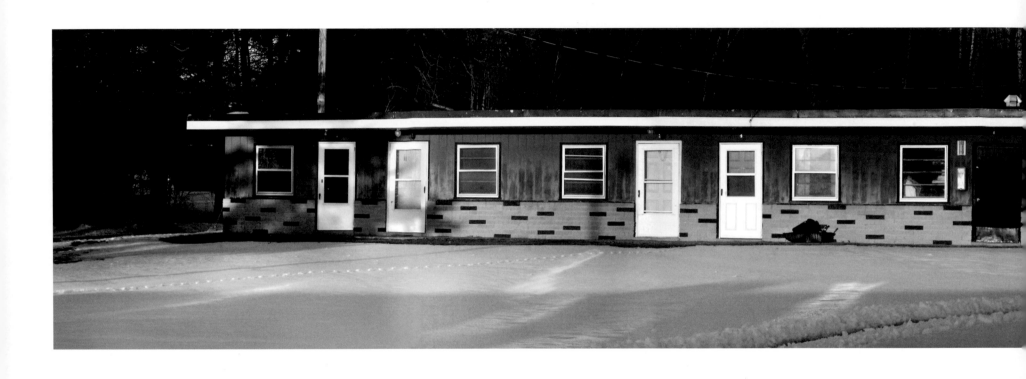

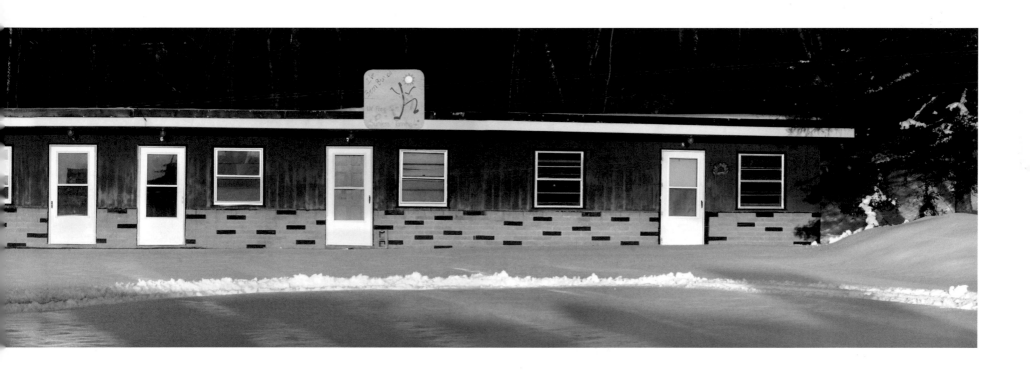

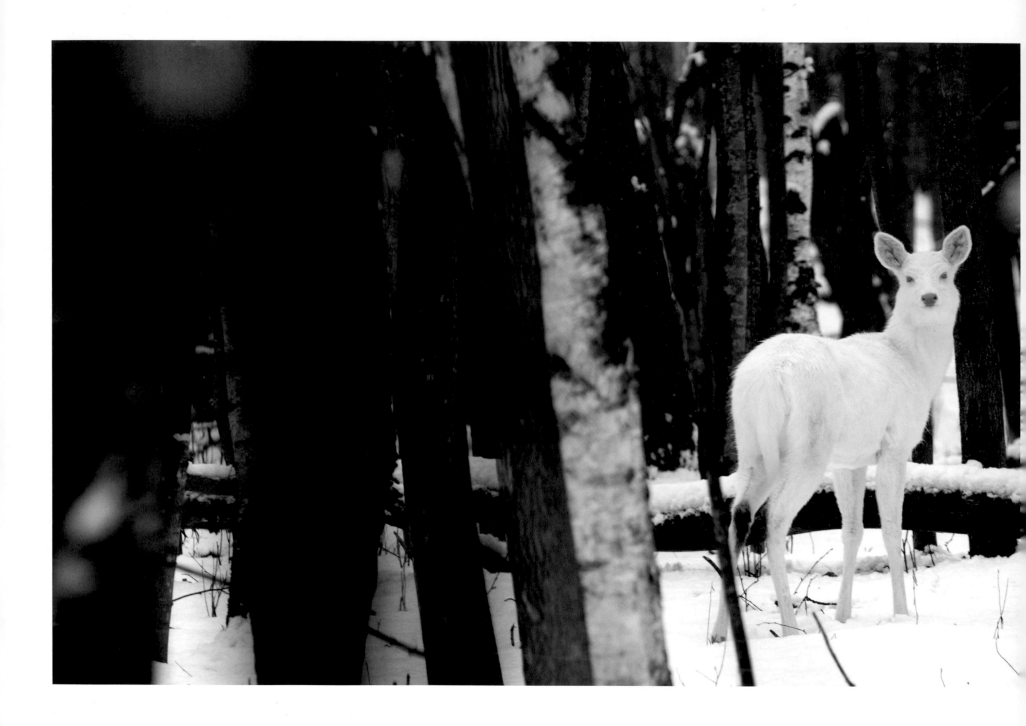

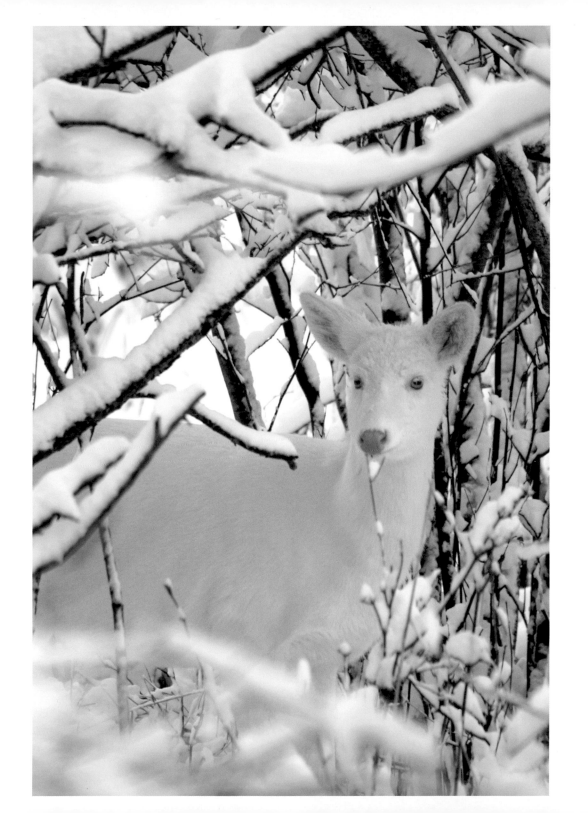

INDEX OF PHOTOGRAPHS

PAGE 8
Country Corner Cafe
Main Street, Isle

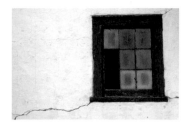

PAGE 9
Farm & Feed Window
Main Street, Isle

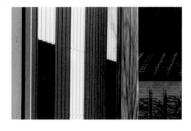

PAGE 10
Industrial Park
Isle

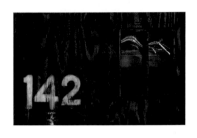

PAGE 11
Ice House
#142

PAGE 12
Farm Structure Roof
Mille Lacs County

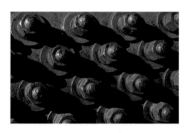

PAGE 13
Close-Up, Old Farm Gear
Mille Lacs County

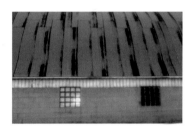

PAGE 14
Farm at Sunset
Wahkon

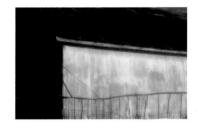

PAGE 15
Storage Building
Wahkon

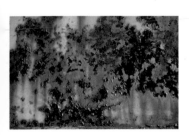

PAGE 16
Close-Up, Rustic Farm Gear
Wahkon

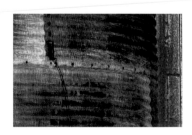

PAGE 17
Rustic Silo
Wahkon

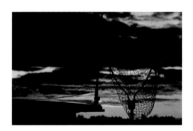

PAGE 18
Landing Net
Scenic Bay Resort

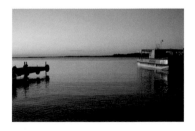

PAGE 19
Fishing Launch
Scenic Bay Resort

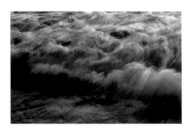

PAGE 20
Waves
North Shore

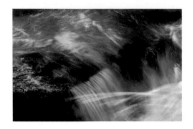

PAGE 21
Shoreline, Water Splash
East Side

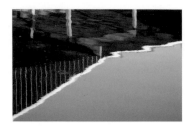

PAGE 22
Water Reflections
Frederickson Marina

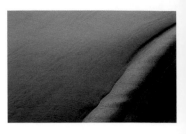

PAGE 23
Sand Beach
South Side

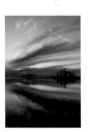

PAGE 24
Sunset Reflections
Hazelglade Reef

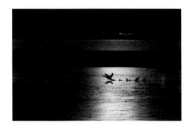

PAGE 25
Waterfoul Takeoff
Hazelglade Reef

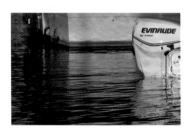

PAGE 26
Boat Motor
Frederickson Marina

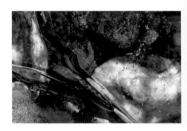

PAGE 27
Ice and Rock
South Side Shoreline

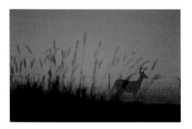

PAGE 28
Buck at Dawn
Lyback Road

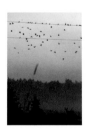

PAGE 29
Buck, Early Morning
Lyback Road

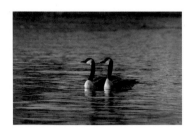

PAGE 30
Canadian Geese
Berg's Bay

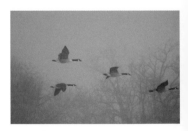

PAGE 31
Canadian Geese
Berg's Bay

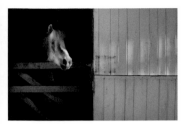

PAGE 32
Haflinger in Stable
Digital Sepia Duotone

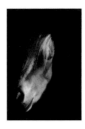

PAGE 33
Haflinger Portrait
Digital Sepia Duotone

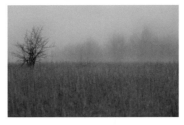

PAGE 34
Secluded Tree
Mille Lacs County

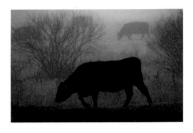

PAGE 35
Cows Grazing
Digital Sepia Duotone

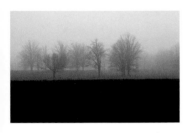

PAGE 36
Misty Treeline
Digital Sepia Duotone

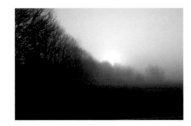

PAGE 37
Sunrise
Galloway Road

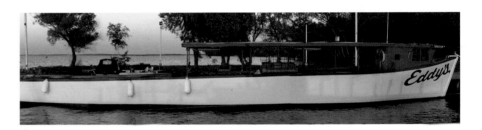

PAGE 38-39
Panorama
Eddy's Fishing Launch

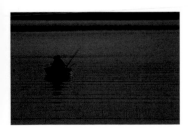

PAGE 40
Fishermen at Sunset
Wahkon Bay

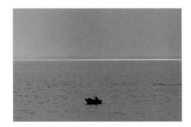

PAGE 41
Fisherman
Isle Scenic Overlook

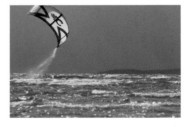

PAGE 42
Wind Kite
North Shores

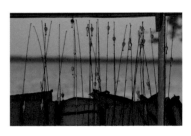

PAGE 43
Slip Bobbers
Fishing Launch

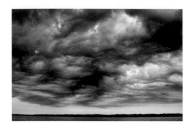

PAGE 44
Ominous Clouds
Before The Storm

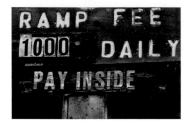

PAGE 45
Exorbitant Fee
Anonymous Resort

PAGE 46
Wood Burning Stove
Friend's Residence

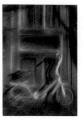

PAGE 47
Old Bicycle
Friend's Property

PAGE 48
Old Truck Door
Sunset Bay Resort

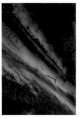

PAGE 49
Old Vehicle Rustic Hood
Sunset Bay Resort

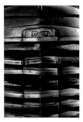

PAGE 50
GMC Truck Grill
Salvage Yard

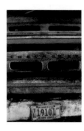

PAGE 51
Old Chevy Truck Grill
Vacated Property

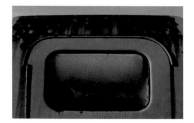

PAGE 52
Oxidizing Truck
Vacant Property

PAGE 53
Old Tractor Gauges
Vacant Property

PAGE 54
Cessna 152
Isle Airport

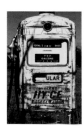

PAGE 55
Aged Petro Pump
Abandoned Farm

PAGE 56
Motion Blur
Ojibwe Powwow

PAGE 57
Jingle Dress
Ojibwe Powwow

PAGE 58
Motion Blur
Ojibwe Powwow

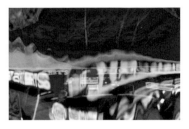

PAGE 59
Window Reflection
Johnson's Portside

PAGE 60
Cafe Sign
Walleye Dundee's

PAGE 61
Grand Casino Sign
Parking Lot

PAGE 62
Four Wheelin'
Soo Line Trail

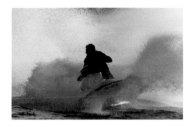

PAGE 63
Watercraft Spray
Chip Frederickson

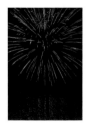

PAGE 64
July 4 Fireworks
Wahkon Bay

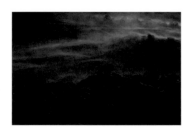

PAGE 65
Sub-Zero Windchills
Out on the Lake

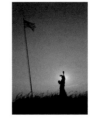

PAGE 66
Statue of Liberty
Liberty Beach

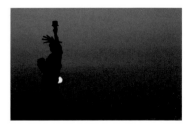

PAGE 67
Statue of Liberty
Liberty Beach

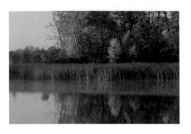

PAGE 68
Fall Trees
Berg's Bay

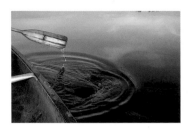

PAGE 69
Canoe Paddle
Berg's Bay

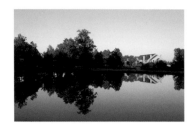

PAGE 70
Fall Colors
Izaty's Resort

PAGE 71
Fall Musky
Johnson's Portside

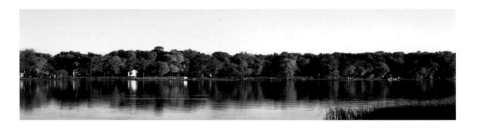

PAGE 72-73
Fall Panoramic
Cove Bay

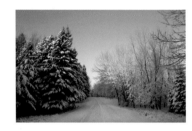

PAGE 74
Snow Encrusted Pines
Father Hennepin State Park

PAGE 75
Hoar Frost
Kathio State Park Tower

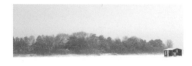

PAGE 76
Secluded Ice Fishing House
Upper Twin Island

PAGE 77
Cabin
Spider Island

PAGE 78
Snow Drifts
Father Hennepin Beach

PAGE 79
Snow Covered Swim Buoy
Father Hennepin Beach

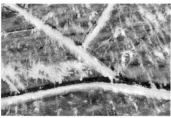
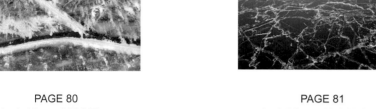

PAGE 80
Aerial from 3000 Feet
Ice Roads on Lake

PAGE 81
Aerial from 10,000 Feet
Ice Fissures and Shoreline

PAGE 82
Ice and Snow on Lake
Close-Up

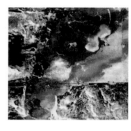

PAGE 83
Burnt Remnants
Merit Enterprises, Isle

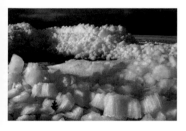

PAGE 84
Snow and Ice Heaves
Izaty's Shoreline

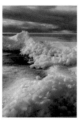

PAGE 85
Snow and Ice Heaves
Izaty's Shoreline

PAGE 86
Launch and Fish House
Eddy's Resort

PAGE 87
Fish Houses
Eddy's Resort

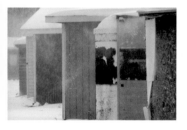

PAGE 88
Fish Houses in Blizzard
Lyback's

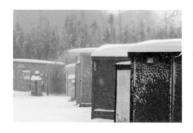

PAGE 89
Fish Houses in Blizzard
Lyback's

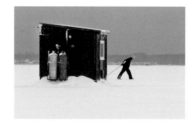

PAGE 90
Effort in Futility
Stationary Fish House

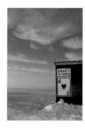

PAGE 91
6 of Hearts
Lyback's Fish House

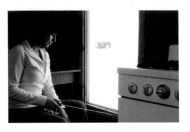

PAGE 92
Ice Fishing
Serenity

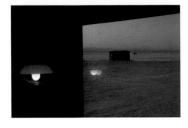

PAGE 93
Fish House Solitude
Lyback's

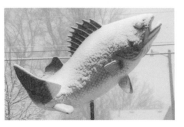

PAGE 94
Snow Storm on Walleye
Main Street, Isle

PAGE 95
Snow Capped Walleye
Johnson's Portside

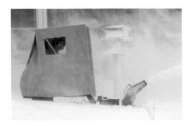

PAGE 96
Minnesota Tough
Blizzard

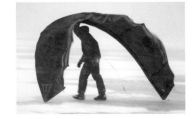

PAGE 97
Wind Kite Surfing
Garrison

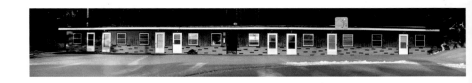

PAGE 98-99
Motel
Isle

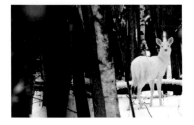

PAGE 100
Albino Deer
Father Hennepin State Park

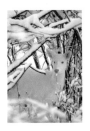

PAGE 101
Albino Deer
Father Hennepin State Park

SPECIAL THANKS

To my amazing wife Rhonda, for all her patience, support, artistic talent and help with promotion of this project. All her positive influence made this dream a reality.

To my Dad, Dick Bennington, for finding Mille Lacs as a vacation spot nearly two decades ago. For all the great times and limits of walleye, the memories are indelible.

Bob Bullivant at bullivantgallery.com, my favorite mentor. For all his incredible help and vast knowledge with digital files, color theory, color profiles, monitor calibration, printing and more.

Chris Welsch, of chriswelsch.com, for his eloquent writing and resolute editing.

Nancy Roe, the coolest Mom ever, for all her guidance and support with publishing, distribution and suggestions.

Steve Roe, for his impeccable keyline and copy expertise.

Chris Roe, my stylish brother, whose inspired art direction truly helped polish this book to a fine shine.

Orin Rutchick of the Minneapolis Photo Center, Sue Lyback, Craig Blacklock, Brett Larson of the Mille Lacs Messenger, and Jenny Jones Holbert for all their valuable input.

Ross Schumacher, my true friend and smooth pilot, for the sweet aerial views at ten thousand feet. Flying in the Cessna was a distinct highlight and cherished memory.

To all my friends, family, neighbors, colleagues, and business associates not mentioned. There are too many to list. Thank you for all the fantastic support. This book would not have been possible without you.

Library of Congress Cataloging-in-Publication Data available.

ISBN 978-0-615-33023-5

First Edition, November 2009

Printed and bound in Canada by Friesens

10 9 8 7 6 5 4 3 2 1

Published and distributed by SuiteDeal1
4567 Grove Street
Wahkon, Minnesota 56386

www.dougbennington.com